Signs, symbols and icons

Pre-history to the computer age

ROSEMARY SASSOON
ALBERTINE GAUR

Harry F. Byrd

Signs, symbols and icons

Pre-history to the computer age

ROSEMARY SASSOON

ALBERTINE GAUR

intellect™

First Published in 1997 by
Intellect Books
EFAE, Earl Richards Road North, Exeter EX2 6AS

Consulting editor: Masoud Yazdani
Copy Editor: Wendi Momen
Designed by: Pardoe Blacker Publishing Limited
 Shawlands Court, Newchapel Road, Lingfield, Surrey

Illustrations: Personal icons. Illegible signatures from the collection of Kathleen Strange
 In part 1, except where otherwise stated, all illustrations come from either
 Albertine Gaur's *History of Writing* or her *History of Calligraphy*.

Acknowledgements

I would like to thank the many friends who have contributed to the second part of this book, beginning with those who have written sections about their work or special interests; Jill Day for her contribution to chapter 5, Isobel Yule and Pat Lorimer who have contributed to chapter 6, Rob Baker and Sarah Head who have contributed to chapter 7, Lesley Ellis and Trevor Harvey who contributed to chapter 8, Adrian Grater and Helen Atkinson who contributed to chapter 9 and Paul Honeywill who helped with chapter 10.

In addition I would like to thank my good friend Briem for his various contributions, Kathleen Strange for the signatures on the frontispiece and several other contributions, Paul Green-Armytage for his insights into Blissymbolics, Rosie Scott of WEC International and Dr Philip Stine of the United Bible Societies for their help with iconic typefaces, Patrick Wallis Burke for his generous help and for permission to use material from Icographic and also Anna Partington for her useful comments. I would like, as always, to express my thanks to my husband, John, for his unfailing support and wise counsel, and to Michael Blacker for his invaluable contribution as designer of this book.

ROSEMARY SASSOON

A catalogue record for this book is available from the British Library

ISBN 1-871516-73-0

Printed and bound in Great Britain by Cromwell Press, Wiltshire

Contents

Preface

PART 1 THE HISTORY OF NON-VERBAL SCRIPTS

Chapter 1 11
A history of symbols and iconography
Early uses of icons
Iconography and memory aids
Maps and property marks

Chapter 2 29
Iconography and writing
From icons to phonetic scripts
Abbreviations in handwritten texts
Numerals and music

Chapter 3 43
Iconography in calligraphy, religion and art
Secret communications
Calligraphy
Religious symbolism
Symbols in secular art

PART 2 ICONOGRAPHY IN THE COMPUTER AGE

Chapter 4 63
Extending the subject of iconographies
Preconceptions to be dispelled
Learning from history
Designing icons

Chapter 5 79
Symbols and special needs
Computers and special needs
Symbol systems and special needs
Working with words and symbols

Chapter 6 93
Symbol systems for visually impaired
Moon and other codes
Unified Braille Code
Guidelines and objectives
Balancing issues

Chapter 7 105
A new iconography for deaf signers
The use of sign graphics in bilingual education
 for deaf children
Sign graphics – sociolinguistic issues

Chapter 8 121
Music Notation
Computers and music notation
The many ways that music has been created;
 from manuscript to computer graphics
Music and typography

Chapter 9 139
Movement notation
Dance notation
Movement notation for clinicians

Chapter 10 155
The way forward
Designing icons for the screen
Design considerations for a visual language
The Atlantis InterArc research programme
A prototype for an interactive iconic hotel booking system
An educational multimedia network in Chile
Conclusions – implications for designers today

Postscript 176

References 179

Index 184

Preface

THE TWO AUTHORS of this book approach the subject of iconography from different directions. In the first part Albertine Gaur takes a comprehensive historic overview, looking at the uses that evolved throughout the centuries, from the earliest known emergence of iconic communication. She brings her treatise up to date with the eye of a historian, asserting the icon as being universal and ever present. Rosemary Sassoon, after a bridging chapter, directs her thoughts to the future and the effects of the computer on iconic communication.

Several practitioners who use various means of symbolic communication in their work, were invited to contribute to the second part of this book. Some of their reports are detailed. In this way parallels between such varied symbol systems can be drawn. Inevitably there are a few overlaps; moreover, different voices speak with different tones. We believe that such a complex subject needs a variety of viewpoints in order to outline the possibilities for the future as well as point out dangers that may lie ahead.

In many ways, particularly in assisting those with special needs, the computer enables tasks to be undertaken that were impossible before. In others it may limit, through a need to simplify and categorise, tasks which although cumbersome by hand, were more flexible. Interactive computer generated iconic communication may increasingly transcend languages, with the prospect of virtual reality taking its part. Even so, there may arise a need for a larger number of specialised symbol systems rather than more grandiose schemes. There are vital issues to balance throughout. All this is breaking new ground in areas where knowledge (and equipment) quickly become obsolete.

From the earliest stages of planning our aim has been to create a snapshot of the state of art at a given moment. However, we have always remained conscious of the pitfalls inherent in such a venture. Future inventions cannot be predicted, nor can anyone be absolutely certain of their use. Those examining the past are limited by other, though not necessarily less potent factors. Research, as indeed all

decision making, depends on the use of available data. Data, however, is never complete. At the very moment we say that the Greeks probably (and it is always prudent to insert the word 'probably') took over the Phoenician consonant script some time between 1000-800 BC, a tourist in a remote corner of Ethiopia might stumble across a Greek inscription dating from 1300 BC. We have just to think of the mysterious Phaistos disc discovered in Crete and (at present) dated 1700 BC. The disc bears the impression of 241 signs arranged in (word?) groups, reading in a spiral either to or from the centre. Those impressions have been made by 45 different punches and nothing similar has ever been discovered anywhere else. So what is this disc – a one off, a left-over from a lost 'civilisation', a fake, or the work of a visionary who saw the possibilities of printing long before Gutenberg or even the Chinese?

The authors have set out to make this somewhat neglected subject comprehensible to the general reader but also useful for the researcher and more serious student. This book reports new ideas that extend the barriers of communication. In doing so, and in particular, in comparing the concepts that have governed iconography throughout history, the intention has been to raise the awareness of how handwritten and machine-generated icons might work together to our benefit.

PART 1

The history of non-verbal scripts

*The present connects the past with the future –
knowing about the past provides a basis from
which we can plan. Signs, symbols and icons have
been part of the collective subconscious of the
human race since earliest times. This part of the
book traces their history from information stored
in rock paintings to present-day computers and
modern information technology. It is thus meant
to provide a basis for the understanding of the
second half of our joint study.*

ALBERTINE GAUR

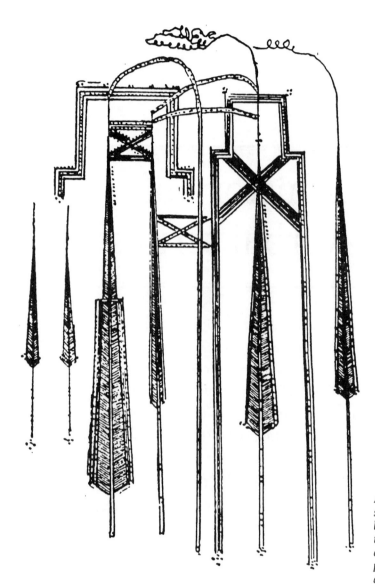

An iconographic 'love letter', said to have been composed by a woman of the Yukaghir tribe living in the far north of Siberia in c. 1892. Part pictography, part memory aid to what was probably a verbal communication, it informs an unfaithful lover of the existence of a rival to the writer's affection; the conifer shaped images represent people. Collected and explained by J. P. Al'kora in Jazyki i pis 'memnost' narodov severa. *Moscow, 1934.*

CHAPTER 1

A history of symbols and iconography

IF THE GROWING importance of systematic writing in the third millenium BC did indeed initiate the destruction of oral traditions, and if the Gutenberg revolution of 1540 eliminated the usefulness of manuscripts, must we then assume that the computer will, sooner or later, make both – printing and writing – obsolete? Should we be alarmed if we see our children playing computer games instead of diligently practising their handwriting and spelling? Or are those children simply preparing themselves for a future that has already arrived? Should we compare them to some 15th century copyists who took advantage of the new invention of printing and turned themselves into writing masters and type designers? Are those computer games in fact the secret recruiting ground for a new computer-literate elite? In other words, do computers, writing and printing have to be mutually exclusive?

Here we should, perhaps, first of all, ask ourselves a few basic questions.

What is the common ground between writing, printing and computers; or better, what is their common objective? The answer to this must surely be: communication. Communication of information essential to support the infrastructure of society. This basic need has not changed since the first picture signs were incised on clay tablets in the Near Middle East some 6,000 years ago in order to record business transactions (Walker, 1987).

What then is the one common element used in writing, printing and on the computer screen? The reply to this is without doubt: the graphic symbol, or icon. The icon is also the most enduring element in any writing system, be it phonetic or ideographic. The icon has great advantages over language-based systems in that it is, within certain limits, universally understood. Computer language, though appearing on a screen, is still written language; it simply

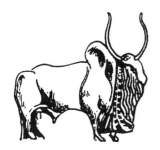

The humped bull appears frequently on seals belonging to the Indus Valley (or Mohenjo-daro) culture; c.2800–2000 BC.

calls for a change in the icon/alphabet ratio (Lanham, 1993). However, in the final analysis, 'a picture is (and has always been) worth a thousand words'. The icon is imbued with an element of universality; it acts, in a way, like a *koan*. A *koan*, a term borrowed from Zen philosophy, is a word that is always appreciated uniquely the moment it is heard. It can be a riddle, a story, or something never heard before, but it has the power to lead directly to enlightenment and knowledge – just as the icon impacts direct understanding.

What then do we mean by iconography in the context of this particular historical study?

The word icon itself comes from the Greek *eikon* which means 'an image'; iconography, from the Greek *eikonographia*, meaning 'a sketch or drawing of an image'. We are therefore not dealing with three dimensional objects, such as statues of saints, but with abstract or pictorial representation of ideas, objects and actions. Such representations have long traditions going back to early prehistoric times, they have played an important role in all civilisation at all levels of development, and they are intimately connected with the storage and communication of information essential to the physical and spiritual well-being of a particular community. As such they were not only vital to the development of writing but they have retained an important place even within strictly phonetic scripts. Icons and iconography have, furthermore, always had a place within religion and art and they are now gaining increased importance in modern communication technology. By standing for itself and assuming symbolic meaning, the icon acts as a catalyst for new developments while at the same time binding the past to the present.

The early use of iconography

Iconography, the ability to formulate and record thoughts and ideas through graphic symbols, goes back to the Stone Age. The first documents of this kind reach us from about 35,000 BC, a time that coincides with the use of colours such as ochre and manganese, and with jewellery. These early examples are often exceedingly simple and consist of no more than kerbs cut at regular interval into pieces of stone or bone; as such they may well have been forerunners

Examples of 'cup and ring' marks from Scotland, c.2000–1500 BC, mainly found in the Argyll area on flat rock surfaces near the sea (Morris, 1977). Various suggestions about the purpose and meaning of these signs have been put forward: places of sacrifice, notices for new immigrants coming from the sea, burial sites, astronomical data relating to the winter sunrise, information about copper and gold deposits in the area, and so on.

of the tallies or notched sticks that commemorated important (numerical?) data or events (success of hunt?), each stroke standing perhaps for a human finger (Harris, 1986). Once emblematic symbols are introduced they are predominantly geometrical and abstract: circles, wheels, loops, combs, triangles, rectangles, arches, spirals, zigzag lines, dots and so on. There are also some simple archetypal images, sometimes sexual in intent, such as representations of the vulva (the spirals and circles have variously been interpreted as either a sign of the vulva or of a water hole), female breasts and phalluses. The images are either incised (petroglyphs), or painted (petrograms); drawings are usually made by dipping the finger (sometimes more than one finger to produce parallel lines) into paint, or by using some instrument, perhaps a stick. An interesting motif is the imprint of a human hand made by putting the hand against the stone surface and painting, or blowing paint, around it – perhaps a primaeval form of signature?

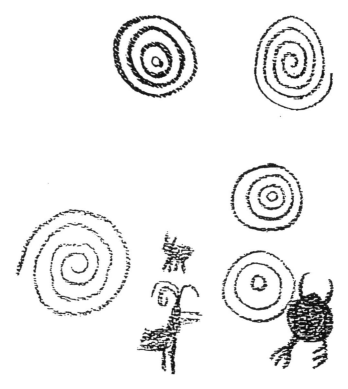

A special technique called 'pecking' (placing small dents made with a pointed flint next to each other) was used by some North American Indians to create an already fairly complex iconography relating to important aspects of tribal life (Stokes, 1980), such as spirals indicating water holes, simple animal forms, or lines showing the course of rivers.

Figurative representations – to begin with pictures of single animals and, more rarely, human beings – come later, in fact not before around 30,000 BC. From an even later period, *c.*10,00–8,000 BC, date the large frescoes like those found in Altamira in Spain and in many other parts of the world, and narrative pictures: hunters surrounding animals, dancers in front of animals or wearing animal masks, or scenes of warfare. Animals are often surprisingly realistic whereas humans appear more stylised – indeed in many cases they are shown by abstract symbols such as squares, triangles, a succession of dots or straight lines (Leroi-Gourhan, 1965).

Iconic representations can also be found on movable objects. Interesting and often quoted are the small pieces of flint dating from *c.*12,000–8,000 BC which the French scholar Piette discovered at the turn of the century near a cave on the Spanish border; many of them are decorated with abstract signs in red and black. The shape of some signs has led to a number of extravagant speculations: that they were forerunners of the Aegean syllabaries, the Semitic consonant script, or even the alphabet (Jensen, 1970). While this must be discounted as most unlikely – apart from the time interval (some ten to fourteen millennia), any comparison based entirely on the outward appearance of individual signs chosen at random from two entirely different forms of information storage and communication is more or less meaningless.

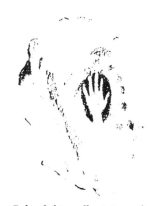

Palaeolithic wall painting of a human hand. The motif of the hand as 'signature' also features in other cultures; it appears, for example, in the sacred paintings of the Aborigines of Australia in much more recent times. In India, when the Sati (the wife willing to burn herself at her husband's funeral pyre – a custom now forbidden) left the home, she would place her hands dipped in ochre on the wall of the house; there the marks remained, an object of reverence and worship.

Palaeolithic, highly stylised, representation of human beings; southern Spain.

This highlights a problem we frequently encounter when looking for the meaning and purpose of such early iconographic representations, a problem we also meet when trying to establish the likely origin of early scripts. As far as available documentation is concerned, both icon and script

Rock drawing found in a cave in northern Spain variously interpreted as showing cave dwellings (left upper side) with footprints below it, and a sign at the right which may be an invitation or a prohibition (Weule, 1915). However, such interpretations are notoriously difficult to sustain since we know very little about the people who made these drawings and the experiences they shared with members of their community.

reach us more or less fully formed and inscribed on permanent material, such as stone, shells or bones. To achieve such a high level of definition, much that would provide us with a link for understanding the origin, and the historic development of icon and script had originally probably been painted, or incised, on perishable materials, such as leaves, wood or sand.

Another interesting point is the fact that iconographic symbols and narratives do not fit neatly into our linear concept of history. They appear, not in strict chronological order, but at a particular point of social and economic development, marking a particular phase, serving a particular purpose. What exactly this purpose was – art, magic, ritual, fertility – has been the subject of much speculation. But less important than the question of interpretation, which must by necessity always be subjective, is perhaps the question of purpose. Here we are on somewhat firmer ground. Whatever the exact meaning of those icons, they were, like scripts, meant to store and communicate information, information important to those who created them and to those who were permitted to see ('read') them.

Remarkable too is the longevity of some motifs. Apart from fertility symbols, certain abstract signs (spirals, circles, swastikas), masked or horned dancers, there is, for example,

Signs on some of the flints discovered by the French scholar Piette in a cave near the Spanish border which could be mistaken for letters of the alphabet; such similarities are however purely coincidental. More pertinent, but in the end equally uncertain, would be attempts at an internal interpretation (e.g. comb, standing for women/spinning?)

the motif of the bull. Representations of a bison appear in many early palaeolithic caves paintings. A South Asian variation of the same animal, the humped bull, is depicted on seals coming from the Indus Valley (now Pakistan), which date from a much later period, c.2800–2000 BC. Another recurring and intriguing motif is the 'Lord of the Beasts', a horned figure, sometimes ithyphallic, which is shown surrounded by animals, such as lions, tigers, elephants or mythical unicorns – to name just a few examples.

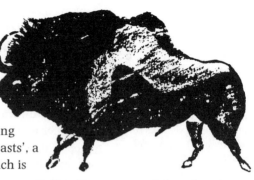

Highly realistic painting of a bison from the Lascaux caves in France; c.30,000–8,000 BC.

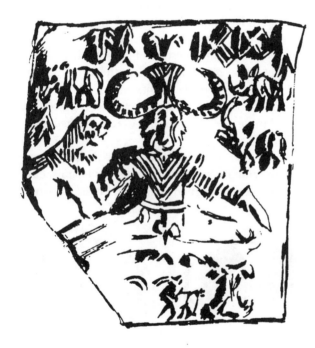

One of the most discussed Indus Valley seals which has given rise to a considerable amount of speculation and interpretation. It shows an ithyphallic figure, perhaps three faced, wearing a horned headdress with a tuft of piled-up matted hair and sitting in yogic posture, surrounded by a retinue of animals. This combination of sexual activity (fertility) and asceticism (posture and hair) reappears 3,000 years later in association with the Hindu god Shiva. The motif of the 'Lord of the Beasts', or the hero associated with wild beasts, is, however quite universal. It appears in the babylonian Gilgamesh epic and in many other cults and religions, including Christianity (Francis of Assissi).

Iconography and memory aids

Iconography supports memory. Whether in the form of simple line drawings or pictorial representations, single or narrative, iconographic images are meant to store a particular information so as to aid the memory of those who will eventually make use of it. Memory aids, or mnemonic

devices, cover a wide field and provide a link between oral traditions and writing. Indeed to some extent all forms of writing, even phonetic scripts like the Latin alphabet, serve the purpose of aiding memory.

In its simplest forms a memory aid can consist of some marks made on wood, stone, cloth, a pillar or even the wall of a house. More sophisticated are such devices as, for example, the message sticks of the Australian Aborigines – rounded wooden batons, sticks or tables incised with marks, grooves or nicks. Those incisions were often made in the presence of the messenger who had the importance of each mark carefully explained to him. The icon is here a vital link between picture and word, between written and oral tradition. Notched sticks enjoyed universal usage: we meet them in ancient Scandinavia, Russia, Italy, in North America and also, to this day, in Africa.

North American wampum belts, which combine pattern and colour, fulfilled a similar function, as did the winter counts of the Dakota Indians which mark each year with a particular iconographic device to record the most important event.

Dakota winter counts are usually written on buffalo skin, sometimes in a spiral from the centre outward, each picture recording the most important events of the year; here the period 1800–70 (Mallery, 1893).

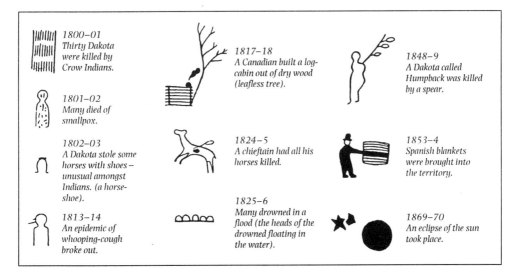

1800–01
Thirty Dakota were killed by Crow Indians.

1801–02
Many died of smallpox.

1802–03
A Dakota stole some horses with shoes – unusual amongst Indians. (a horse-shoe).

1813–14
An epidemic of whooping-cough broke out.

1817–18
A Canadian built a log-cabin out of dry wood (leafless tree).

1824–5
A chieftain had all his horses killed.

1825–6
Many drowned in a flood (the heads of the drowned floating in the water).

1848–9
A Dakota called Humpback was killed by a spear.

1853–4
Spanish blankets were brought into the territory.

1869–70
An eclipse of the sun took place.

The Moche, a pre-Inca people of Peru, used beans marked with dots, circles, parallel lines or comb-like shapes to convey messages and information. The exact nature of this

Beans were used for counting by the Moche people of Peru. Those marked with special designs may have had additional purpose and meaning.

form of iconography is still unclear. Leather pouches filled with such marked beans have been found in Moche graves. Rafael Larco Hoyle, who excavated many Moche graves, was convinced that these signs constituted a system of writing comparable and possibly related to that used by the Mayas of Central America (Bankes, 1977); but no key to its decipherment has as yet been found. Runners holding pouches and moving with great urgency feature prominently on some pottery vessels – whatever the actual message, we can assume that sending the marked beans played an important role in supporting the infrastructure of Moche society and that, at the very least, they constituted a form of memory aid: numerical, verbal or both.

An interesting claim was made in 1970 by the German scholar Thomas Barthel in the course of an International Congress of Americanists held in Lima. Barthel stated that in addition to *quipus* (knotted strings recording mainly numerical data), the Incas of Peru possessed a well developed form of iconographic writing consisting of geometrical designs, *tocapus*, found as decoration on wooden cups and textiles. Each individual sign is supposed to equal a particular character; Barthel made the further claim that he had already identified 400 different script signs and that with the help of notes made by Spanish missionaries, he had succeeded in deciphering 50 of them (Barthel, 1972). However, nothing has since been heard of this discovery. It is indeed unlikely that the *tocapus* constituted a specific,

Leather pouches filled with marked beans have been found in Moche graves; they also feature quite prominently on some pottery vessels where runners are shown carrying them with great urgency to some unknown, but no doubt specific destination.

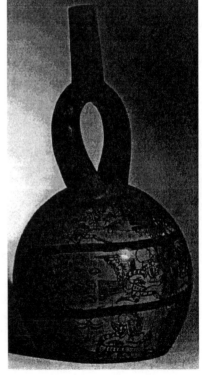

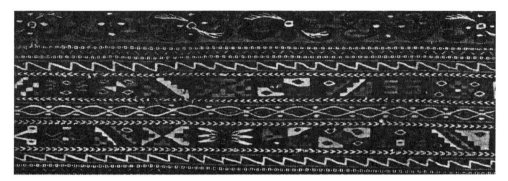

and now forgotten, iconographic form of writing, though they may well have been a mnemonic device.

A rather special memory aid is the tally. In their simplest form tallies are wooden sticks into which notches or grooves have been cut to assist in the memory of particular objects, numbers or events: the number of animals hunted, enemies killed, horses required in a certain camp, the days of a journey, the number and, depending on the shape of the individual marks, quality of goods sold, and so forth. The main purpose of a tally has always been the recording of debts. Once a stick has been marked it can be split length wise, giving both the creditor and the debtor an incorruptible account of the amount of money or goods involved. In England, the chief interest of the tally centred round its public use. Soon after 1100 AD tallies became recognized forms of receipt for payment into the Royal Treasury (hence the term 'tally clerk') and continued as such until 1826.

But tallies can have a much wider use. Some scholars go so far as to suggest that tallies played an important role in the development of the Chinese script – in so far as tallies were forerunners of written contracts, perhaps assisting business, or in this case, administrative transactions. According to this theory, the original notches on tallies were at a later period supplemented by incised and painted ornaments and symbols; once writing had become established, characters were used, first in addition, and eventually in place of such ornamentation. The earliest forms of Chinese writing material, narrow slips of wood or bamboo, have probably encouraged such speculations. Furthermore, though perhaps purely anecdotal, at the

beginning of the century the Swedish explorer Sven Hedin discovered in eastern Turkistan a wooden tablet that bore audit officials' check marks and signatures; the board had been split vertically, thus providing each party with documented proof of the original contract (Jensen, 1970).

An mnemonic icon can also have linguistic implications; at times it stands, not for a word, but for a whole sentence. Many decorations used by the Ashante people of West Africa on the walls of houses and shrines represent proverbs. A knowledge of proverbs was an essential element in everyday life and vital for those trying to advance in Ashante society. Proverbs expressed traditional wisdom and were used to clinch debates and arguments. Their iconographic representation may not always have had a fixed meaning but it provided the starting point for a mental or spoken chain of sayings (McLeod, 1981). Thus the image of a bird turning its head backwards can mean 'a person should not hesitate to turn back to undo past mistakes'; that of a crocodile grasping a mudfish in its mouth can either stand for 'if the mudfish gets anything it will ultimately go to the crocodile' or 'only a bad crocodile eats a creature that shares the same hole in the river bed'. Here the icon acts indeed like a *koan*, instantly recalling a riddle designed to give a message to those who look at it.

Iconography to represent whole sentences, notices, or warnings is also used in our own environment. This traffic sign states quite clearly: 'there is no bridge at the end of this road and if you drive on you will fall into the water'. Incidentally, the practice of representing water by one or more zigzag (or wavy) lines has persisted throughout history, indeed the Egyptian hieroglyph for 'water' was written in this way.

Maps

A special type of memory aid are maps that provide graphic representations of parts of the earth. Maps pre-date literacy: hunting-trails, the route to a neighbouring tribe or to a water hole, appear in some cave paintings. The earliest dated map is a Babylonian clay tablet from 2300 BC. Until the 18th century, when a new type of scientifically based form of cartography developed, maps were based on personal experience or on the reported (real or imaginary)

observations of travellers, sailors and adventurers. Most of them served a definite practical purpose and iconography played a dominant part in their presentation.

Maps relate to the layout, and with it very often also to the ownership – real or spiritual – of land and property. The Aborigines of Australia have mystical maps, *churingas*, that tell the story of a particular totemic ancestor and the land on which a particular clan lives. *Churingas* are stone or wooden tablets engraved with abstract line designs. They record how during 'dream time', when the land was still undifferentiated, those ancestors, mystical beings who had the characteristics of both animals and human beings, shaped the land on which the clan lived and by doing so established the clan's claim of ownership as well as precedents for human conduct.

Iconography was an important feature of Chinese, Islamic and medieval Western cartography. In recent times iconographic elements have seen a revival in the

Among the Australian Aborigines churingas *map the mystical journeys of the ancestral 'dream time' people, together with the land belonging to the clan. A circle could stand for the camp of the 'dream time' people, and for the place where they first emerged from the ground. Other circles might show them sitting around their camp fire, and the lines running from the centre in all directions the tracks they used to travel to other sites; foot prints leading to small spirals may indicate the paths taken to water holes or other important (sacred?) sites.* Churingas *played a decisive part in Aborigine culture. They were hidden in sacred places which women and uninitiated youths were forbidden to visit.*

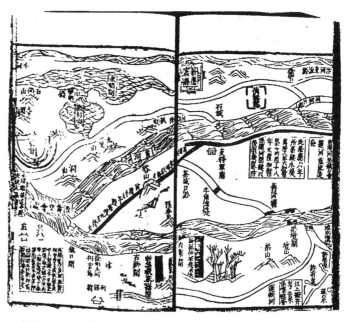

A 16th century Chinese map.

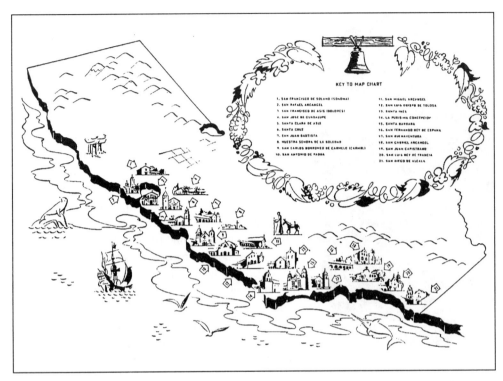

KEY TO MAP CHART

1. SAN FRANCISCO DE SOLANO (SONOMA)
2. SAN RAFAEL ARCANGEL
3. SAN FRANCISCO DE ASIS (DOLORES)
4. SAN JOSE DE GUADALUPE
5. SANTA CLARA DE ASIS
6. SANTA CRUZ
7. SAN JUAN BAUTISTA
8. NUESTRA SEÑORA DE LA SOLEDAD
9. SAN CARLOS BORROMEO DE CARMELO (CARMEL)
10. SAN ANTONIO DE PADUA

11. SAN MIGUEL ARCANGEL
12. SAN LUIS OBISPO DE TOLOSA
13. SANTA INES
14. LA PURISIMA CONCEPCION
15. SANTA BARBARA
16. SAN FERNANDO REY DE ESPAÑA
17. SAN BUENAVENTURA
18. SAN GABRIEL ARCANGEL
19. SAN JUAN CAPISTRANO
20. SAN LUIS REY DE FRANCIA
21. SAN DIEGO DE ALCALA

preparation of maps made for tourists that concentrate mainly on pointing out commercial facilities, or areas of historic or scenic interest.

Property marks

Another important form of iconic representation are marks (abstract and/or pictorial) used to identify property. They act as a signature, either of an individual or of a particular clan or group, and by doing so establish authority and a claim to ownership; in the Near Middle East they have also played a decisive role in the development of systematic writing.

Property marks have a long history and can claim universal usage. Nomadic herdsmen and settled cattle breeders alike have always marked their livestock by branding. Societies with an economy depending on slave labour have often used similar devices. This branding or marking (tattooing) can also be voluntary whenever an individual wishes to demonstrate his or her complete

A contemporary tourist map of the Franciscan mission stations that had been established between 1769 and 1823 along the California coastline between San Diego and San Francisco.

identification with a particular group or mode of worship. For example, in India, Vaishnavites and Shaivites paint special distinctive marks on their foreheads to demonstrate adherence to their respective deitites – Vishnu and Shiva.

Mark used by the English printer William Caxton (b. 1422).

Into a related category fall clan and house marks which in turn can be used for signing documents – similar to the three crosses made by people unable to read and write. Iconic marks can also establish the value, or the authorship, of a particular product. Examples are the pottery marks from ancient Egypt; ceramics marks; hallmarks made on gold and silver, which guarantee value; the marks of masons from the ancient Aegean region, Palestine, Anatolia and medieval Europe; watermarks which serve to identify fine paper; printers' marks; and the various trade and guild signs such as the barber's brass bowls or the locksmith's key, as well as signs seen outside individual inns.

A variation of such property marks are heraldic devices that document the belonging to a (usually prestigious) family or lineage, regimental badges, banners and national flags.

Watermarks created by wires laced into the laid mould.

The term heraldry itself appears in Western Europe for the first time in the 12th century, but the practice itself is much older and more widespread. Heradotus, writing in the 5th century BC, claims that the Carians were the first to wear crests on their helmets and devices on their shields, and that they taught this practice to the Greeks (Wagner, 1978); family shields were indeed in documented use in Athens from around this period. In Europe, heraldry is closely connected with the feudal system by which the lord grants land to a vassal which is then held as a hereditary fief in return for certain, usually military, services. This created a class of warriors who formed close (identifiable) groups and protected their privileges against outsiders. The system grew up in France and was brought to England with the Norman conquest. Similar systems existed in Egypt, Assyria, China, Japan, India and Mexico.

In recent times property marks have seen a modified revival in the form of logos adopted by institutions, political parties and commercial firms. Logos are carefully designed, often at much expense, by outside consultants and graphic

Property marks found on vessels dating from the early Stone Age.

Pottery marks from ancient Egypt.

Clan or house marks from Scandinavia.

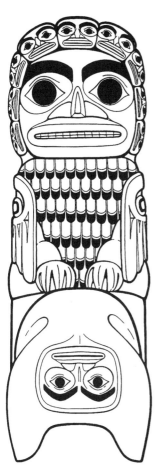

Amongst the native Americans totems represent the identity of the clan and the person belonging to it; totem poles record their history and composition. This is the upper part of a Haida pole from British Columbia, carved by the chief of the Wolf Clan, which shows a face wearing the chief's crown made up of human faces; below a dragon fly that played an important part in the clan's history.

artists, to advertise the prestige, authority and the homogenous nature of the group responsible for a particular idea or product. An interesting point is the fact that some modern logos bear no relation to the product or idea they advertise. It is here perhaps worth noting that in the 5th century BC Heraclitus used the term 'logo' to designate the orderly pattern that is half hidden, half recognizable.

A highly sophisticated form of property mark is the seal. In ancient Mesopotamia seals bearing personal patterns, which served as 'signatures', were used as early as the

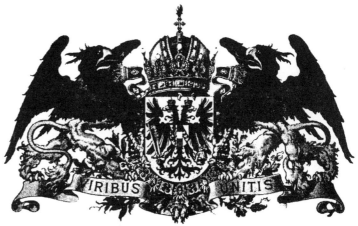

The coat of arms of the Austrian Emperor, Joseph I (1678–1711) which, like the totem pole, records history and the right to possessions of the Hapsburg family.

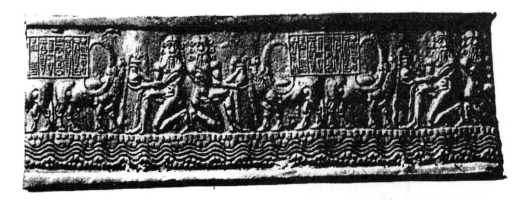

4th millenium BC. After 3000 BC, when trade and commerce rapidly gained in prominence, their importance increased – despite the fact that by then writing was well established. Seals bearing pictorial images, many of them ancient cult symbols, influenced the development of writing in ancient Crete. They were also of great importance in the distinctive and still somewhat mysterious culture that flourished in the Indus Valley (Harappa and Mohenjo-daro) from about 2800 BC onwards; in fact, the only documented evidence of the still undeciphered Indus script is to be found on seals.

In Mesopotamia, where writing evolved around property and business transactions, most early clay tablets and seals give lists of proper names, goods and numbers (numbers being shown by circular impression). Later, the Sumerians invented the cylindrical seal which combined written passages with pictures; such seals reached a high level of artistic and technical excellence and supply valuable information about life in the ancient city states.

Seals from the Indus Valley show either abstract symbols (like the swastika) or a combination of a pictorial representation (a unicorn?) and short inscriptions written in the still undeciphered and highly iconographic Indus Valley script.

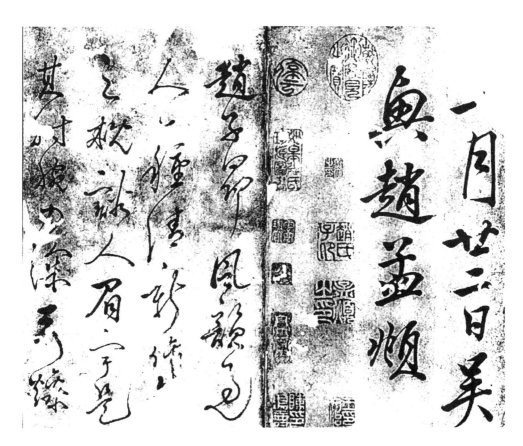

Chinese Imperial seals are mostly inscribed with a particular calligraphic style called the Great Seal Script which has retained strong iconographic and pictorial elements. Opening pages of an album of calligraphy attributed to the styles of two famous Chinese calligraphers of the 14th and 16th century, respectively. On the left side of the right hand page are the seal impressions of previous owners.

In China, personal seals have been, and still are, used by painters and calligraphers alike to authenticate their work. Such seals form an integral part of the work itself; their visual beauty, as well as their ability to identify authorship, greatly increases not only the artistic but also the commercial value of a particular work. Moreover, in the Far East it has always been a habit of owners of a particular art object to attach their own seal impression to it, thus providing us with an accurate and valuable account of its provenance.

If seals act like signatures then a handwritten signature can at times become so divorced from the legible representation of an actual name that it is hardly more than an iconic device representing the writer – a form of personal or personalized logo. The phonetic element (signatures are after all supposed to represent phonetic elements – the

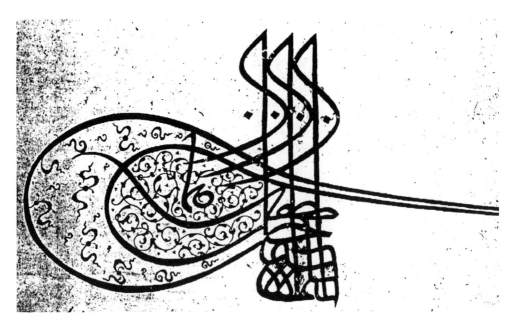

sounds of the signator's name) are then not only greatly neglected but very often altogether absent. In a way, signatures allow us an insight into the way individual people see, and often value, themselves – or would like others to see them (Sassoon, 1993).

Charlemagne (742–814), who was responsible for the creation of one of the finest calligraphic styles ever known in Europe, never fully mastered the art of writing and his signature was simply a cross with his initials and R (for Rex).

A wide variety of iconographic expressions can be used for creating signatures. A signature can be a seal (see above), a recognisable written name, or an icon: the American painter J. A. M. Whistler (1834–1903), for example, used the picture of a small butterfly in place of a signature.

The Ottoman Turks developed a special device called Tughra which represented the name of the Sultan and was used to authorize documents. As a safeguard against forgery, Tughras grew increasingly more complex and any unauthorized use carried the death sentence (Tughra of Suleyman I, r. 1520–1566).

A contemporary signature.

CHAPTER 2
Iconography and writing

Iconographic communications become legible within an appropriate context where a particular and limited amount of experience and knowledge is shared by all participants. This holds true for prehistoric rock paintings, tribal communication systems, early scripts and finally our own computer-based information networks (see the 'Windows' – iconic representations – used in modern computers).

Proto-Elamite clay tablet from Mesopotamia from the 3rd millenium BC. It shows horses heads and numerals (a shield for 'one', a circle for 'ten') – an inventory, the documentation of a sale, or the dedication of a certain number of horses?

A passage from the Aztec Codex Boturini, pre-conquest Mexico. It tells how four Aztec tribes ready to migrate (the four tribes are shown at the left; foot prints indicate their intention to go away) come to a sacred place (shown in the centre by an altar besides a broken tree) to bid farewell to eight related tribes (shown at the right). Though the Aztec writing system contained phonetic elements, the basic meaning of this passage can be deduced from the iconographic components.

Scholars trying to establish theories about the origin of writing frequently asked the question: did a purely iconographic script ever exist, does our own form of writing go back to it (perhaps via the Egyptian hieroglyphs), and, even more important, is a purely iconographic script possible?

An iconographic script would have advantages as well as disadvantages. On the positive side is the fact that pure iconography has inherent elements of universality by not being bound to a particular mode of verbal expression, or language. But though the icon communicates directly, to understand its meaning clearly a pool of shared experience is necessary. Such shared experience does exist at a certain

level of social and economic development. Foodgatherers, hunters, primitive herdsmen and subsistence agriculturists form coherent groups who share experience. By not producing any

significant amount of surplus, they do not possess enough disposable property that could serve as a means of exchange. In consequence, they do not need an administrative mechanism to organise and protect property. At this stage religion and society, history and legend are closely interwoven, the infrastructure of society is supported

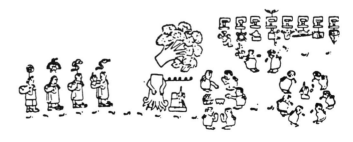

by oral traditions, helped perhaps by memory aids and pictorial narratives. Since all experience is shared by the group the icon can act as an unambiguous means of communication.

A purely iconographic script does however have certain disadvantages. Apart from the question of shared experience (which limits it usefulness to a particular group) there is the exceedingly large number of signs necessary to express any coherent information. The picture of a leg can stand for 'leg', by inference it can also stand for 'to go', but several more signs would be necessary to construct sentences such as 'yesterday I nearly went'; and so forth. Moreover, to make the information clearly legible to a wider audience, the sign itself must sooner or later become codified and conventionalized to make sure it is written in the same way every time.

Between the 3rd millenium and about 600 BC the highly abstract and convention-alized cuneiform script of Mesopotamia emerged from the original Sumerian pictograms. The reasons for this change were manifold. Sumerian picture signs had been written with a reed stylus on square tablets, the signs being incised from top to bottom, in columns running from right to left. Later, the pointed stylus was replaced by a wedge shaped one and rectangular tablets came into use. These tablets had to be held differently and by turning them 90° to the left to make writing easier, the script became both, wedge-shaped (cuneus – wedge), and devoid of pictorial elements; the direction of writing too underwent changes, running now from left to right with each line written from top to the bottom.

As the complexity of society increases there arises the need for a more coherent and also more clearly legible form of communication. In other words the step from iconography to systematic writing is taken when changes in the social and economic pattern necessitate a different form of information storage and communication. In the ancient Middle East this happened sometime in the middle of the 4th millenium BC, when, slowly at first, a new type of agriculture developed that brought about changes as far reaching as those of the industrial and scientific revolution of the 18th and 19th century in our own hemisphere. As a result, a new type of economy developed which depended greatly on organised labour (for irrigation – the land

The present example shows five signs: a sitting bird meaning 'bird'; a bull's head for 'ox'; a star for 'sky', 'heaven', 'god'; two wavy lines indicating water for 'water', 'seed', 'father', 'son'; and two trees on a plot of land standing for 'orchard', 'greenery', 'to grow' or 'to write'.

The hieroglyphic script of ancient Egypt contained (like the cuneiform script of Mesopotamia) phonetic as well as iconic elements and functioned by manipulating five basic components:
1. The drawing of a particular object could stand for a particular word denoting this object.
2. A concrete, visible action could be represented by its most characteristic elements.
3. A word (or in the case of the Egyptian script, the consonants representing this word) could be expressed by the picture of an object containing the same sound (i.e. a rebus).
4. In addition, the Egyptians had 24 single consonant (i.e. phonetic) signs.
5. To eliminate ambiguities, which arose in connection with the use of phonetic signs, the Egyptians used determinatives (sense signs) which were added at the end of a word to indicate the sphere to which this word belonged (e.g. the sign of a man added to the sun disc standing for s-n could only mean 'son').

between the Euphrates and the Tigris is infertile for 8 months of the year), the administrative control of the resulting surplus (trade – creating a need for contracts and laws regularizing the exchange of goods), and the supervision and defence (armies) of ever more densely populated areas (increased production caused the development of cities/states). In this new, centralised economy the officials of the palace and the temple (the twin institutions around which life revolved) needed a more flexible form of information storage than either human memory (oral traditions) or a system of property marks (seals/icons).

We can thus say that to facilitate systematic writing the icon becomes at first conventionized and codified and eventually begins to represent, usually by a method of rebus transfer, definite phonetic elements. Thus the iconic representation of a sun disc can, for, example, simply be read as 'sun'. It can however also be used to represent phonetic element, namely the sound of the word 'sun'. In this capacity the picture – now representing a sound unit – can be used to express other words, such as for example 'son', or it can form part of other words, namely *sun*-day, *sun*-y, *sun*-der, or *sun*-g. This in fact, was the way in which the ancient Egyptian hieroglyphic script (Davies, 1987), and also the cuneiform script of Mesopotamia functioned.

Apart from writing, iconography also played an important role in ancient Egypt and permeated all aspects of life, thought and religion (Moore, 1977). Before the decipherment of the Egyptian script in the last century, hieroglyphs were widely considered, not a form of writing, but enigmatic symbols full of fundamental meaning and

1	= leg	= eye	
2	= to go	= to weep	
3	= p-r (house)	= n-b (basket)	
4	= r (the mouth)	= s (folded cloth)	= h-t-p (a loaf on a mat)
5	= (identifying) plant (sphere)	= (identifying) water (sphere)	= (sign for book roll identifying abstract ideas)

wisdom. Some of them did indeed hold such a position and have at times found their way into other religions. For example, the hieroglyph (or ideogram) for *ankh*, which is put on the chest of mummies as a symbol of eternal life, reappears in Coptic Christianity as an alternative form of the cross. The Djed pillar, a representation of the God Osiris, is often shown holding a crooked sceptre and a flail, symbols which in Christianity are seen as the shepherd's hook and the flail (as whip) – both associated with the divine mission and passion of Christ.

Egyptian hieroglyphs were also instrumental in the development of cryptography, secret communications (from the Greek *kryptos* – hidden, and *graphein* to write) used in connection with governmental, military, diplomatic, and to some extent also commercial communications. Towards the end of the Ptolemaic period (332-30 BC), and increasingly so during the time of the Roman emperors (30 BC-337 AD), certain hieroglyphic signs were deliberately substituted by similar looking ones, creating a wholly bizarre form of spelling, unintelligible to all but the initiated. Altogether three different systems seem to have been in use, much to the confusion of scholars who, during the last few centuries, tried their hands on the decipherment of the Egytian script.

The advent of systematic, phonetic writing did, however, not spell the end of iconography. Many otherwise phonetic scripts retained a high level of iconographic elements. Maya writing, for example, which between *c.* 200 BC-1500 AD

The Egyptian hieroglyph for ankh, *used as an amulet in tombs to indicate the triumph of life over death, and often shown being presented by the gods to the Pharaohs, reappears in Coptic Christianity as the 'looped cross'.*

The cosmic Djed *pillar (made in peasant rituals from an upright sheaf), a symbol of the god Osiris can be depicted carrying the royal emblems: the crooked sceptre and the flail. The crook (of the shepherd) and the flail (as whip) are also associated with Christ in his capacity of divine shepherd and saviour; like Christ, the Egyptian Osiris underwent death and resurrection as an important element of his cult and mission.*

i ii

The iconic element of Egyptian hieroglyphs reflected important features of Egyptian life; individual signs were often sensitive to historical and/or conceptual changes. The two hieroglyphs here shown both stand for 'scribe', but the earlier one (i) shows a reed pen-case and a bag, the later one (ii) a wooden pen-case and a water jar, mirroring changes in writing materials.

Maya writing made use of logograms (icons) and the (phonetic) rebus principle (transferring the sound of one word to another and using the same sign for both) in a manner similar to that employed in ancient Egypt. The three glyphs 'vulture', 'torch' and 'a bundle of pine', clearly recognisable even by those not conversant with Maya writing, could thus also be used to represent (phonetic) parts of other words (affixes, etc).

The Aztec writing system functioned in a similar way. In the first century after the Spanish conquest of Mexico, Christian missionaries tried to make use of the combination of iconographic and phonetic elements to convey their own message, here the beginning of the Lord's Prayer in Latin.

supported a complex culture in Central America, used many pictorial representations – animals, birds, hearts (a symbol of human sacrifice), hands, crossed legs, axes and so forth (Thompson, 1972). Important elements and features of Maya life like deities, or the months and days of the all prevailing calendar, were shown in this way. By retaining a wealth of iconographic elements the texts became legible even to those without a high degree of literary competence (Houston, 1989). Iconographic elements also distinguish the script of the Aztecs, who emigrated to Mexico in the 12th century and who, four hundred years later, astounded the Spanish conquistadors by the sophistication of their civilization. Incidentally, the method of employing pictures, illustrations and symbols to assist those with an only rudimentary knowledge of literacy can also be found in some Buddhist and Hindu manuscripts, Christian pamphlets, and it is still a distinguishing feature of our present day tabloid press.

| pami-tel | te-te | noc-tli | te-te |
| 'flag' | 'stone' | 'fig date' | 'stone' |

pa-te noc-te – 'Pater Noster'

To illustrate both the advantages and disadvantages of an even partly iconographic writing, the Chinese script provide a good example. There is the large number of signs: 3,000 to 4,000 characters for everyday use, 50,000 for scholars studying the classical texts (as compared to the Latin alphabet which now uses some 26 signs). Why then has the Chinese script been so successful, lasting, apart from comparatively few minor remodellings, well over 4,000 years? Simply because as a concept script Chinese does not depend on the spoken language. This made it, throughout Chinese history, an ideal means of communication in an empire whose people spoke a large number of different dialects yet were all ruled by the same centre.

 Despite the presence of phonetic elements, iconography
still forms the basis of Chinese writing. This idea has
recently been challenged by some scholars (DeFrancis,
1989), but overall their theories are inspired less by
historical data than by a desire for 'political correctness'.
The fact remains, that unlike other systems, the Chinese
script does not primarily represent the sounds of a
particular language but the concept by which language as
such can be represented. There are close connections with
painting and with the visual representation of natural
objects; the calligrapher, for example, is taught that the
strokes of each character should resemble objects observed
in nature. Most characters have their origin in pictures and
even today this pictorial origin is often clearly visible.

	Old form	*New form*
child	뫃 뫃	子
tree	米	木
gate, door	門	門
arrow	矢	矢
word, to speak	言	言
rain	雨	雨
dog	犬	犬
large snake	巴	巴
hand	手	手
field	田	田

A set of Chinese characters, ancient and modern, which demonstrate the original, pictorial/iconic, root of Chinese writing.

This leaves us with the question: did most scripts develop
more or less naturally from (pictorial) iconography? Those
in favour of this theory often quote the scripts which in the
course of the later 19th and the early 20th century evolved,
among often quite simple communities, in Africa, America
and Alaska (Schmitt, 1980). In most cases their
development seems to follow a similar pattern. The date of
the invention and the name of the inventor are known
(usually, and this is were we have to be wary, somebody

familiar with the alphabet or, more rarely, the Arabic script). In most cases the script begins with iconographic designs (similar perhaps to those already used within the tribal community), moves towards a word (picture) script, then to the introduction of phonetic elements, mostly via the rebus principle, to culminate finally in a syllabic script (Jensen, 1970).

Let us take for example the Bamum script, one of the most important African scripts of this nature, which was invented by King Njoya and some of his dignitaries between 1903 and 1918. At first purely a picture script, it underwent a number of reforms which introduced simplification of signs and a progressive use of phonetic

Between 1903 and 1918 the Bamum script of Africa changed from a purely iconographic into a syllabic form of writing (Jensen, 1970/Schmitt, 1980).

values. However, while this is no doubt interesting, it can not automatically serve as basis for an overall theory of the origin of writing. We should here perhaps remember that the earliest (prehistoric) development moved from abstract (script related?) to pictorial (art related?) icons. In fact the overall pattern of development seems to have run in two consecutive circles: abstract (script) signs, to picture (art/magic related) ones, to abstract writing systems, and back to pictures and icon related (computer) signs.

Abbreviations

Iconographic elements have retained a place in nearly all phonetic writing systems. The Latin (or Roman) alphabet goes back, via the Etruscan script, to the Greek alphabet. This alphabet, in turn, was a modification of the Phonecian consonant script which the Greeks adopted sometime between 1000 and 800 BC. Alphabets are thought to be purely phonetic scripts where one particular sound unit is

represented by one particular sign. This of course is no
longer strictly true. After the disintegration of the Roman
Empire in the 4th century AD, and the consequent rise of
national states and languages (and national forms of
alphabetic writing), many new sounds appeared for which
the letters of the original Latin alphabet had no longer any
adequate representation. This problem had to be solved by a
number of (written) compromises: e.g. ø, ä, ç, etc; and also
by making one and the same character represent a number
of quite different sounds (the possibilities of pronouncing
the character 'a' in English is an example). In addition,
iconographic elements, in the form of abbreviation, began
to play a part even in Latin texts.

In the course of the Middle Ages professional scribes, in
order to save time, space and effort, developed and used a
large number of such abbreviations. Their readers were
familiar with the texts (biblical) and the language (Latin) –
an important precondition for the successful use of
iconographic devises. However, with the growing
complexity of the texts, and the increased demand for
manuscripts, mistakes occurred, some abbreviations became
obscure, other developed at the whim of a scribe. This
became even more problematic once national languages
were used side by side with Latin. After 1200 AD, with the
development of secular universities and the creation of
scribal workshops, a larger number of abbreviations
developed, not all of them based on well-known principles
and traditions (Brown, 1990).

Scribal abbreviations fall basically into a number of
different categories: e.g.

They can work on the principle of suspensions:
non n̄ ō, est ē, cum c̄,
quorum, quo q𝓊o𝔞 , or incipit incip̄.

Or they can use contractions: eg.
per/par/por ℘, pro ⅌, ergo ⅔,
nisi ṅ, esse ēē, or vel 𝓊𝔩'.

Then there are those abbreviations and symbols derived
from the so-called *Tironian Notae*, a system of shorthand

invented by Marcus Tullius Tiro, the secretary of Cicero in about 58 BC. Originally used to record speeches made in the Senate, the system again became influential during the Middle Ages. Some typical and frequently used examples are:

et 7, contra ꝫ, autem hᵘ,
enim ꝉꝉ, or est ↶ .

Finally there are the abbreviations of the *nomina sacra* such as:

Christus Xps̄, deus ds̄,
spiritus sps̄, or sanctos scōs.

Medieval (and later) texts also used special abbreviations for the days of the week:

Monday ☽ , Thursday ♃,
Tuesday ♉ , Friday ♀ ,
Wednesday ☿ , Saturday ♀ and Sunday ☉.

There were further abbreviations to denote metals:
Gold ☉ , Silver ☽ , Iron ♂, or
copper ♀ ;

and elements:
Water ▽, or Wind △ .

In due course authors made up their own abbreviations, using them, often legible only to themselves, as a form of shorthand in personal notes, diaries or manuscripts. The following examples are taken from a manuscript entitled *Notitiae Malabaricae* written in 1688–9 by the German traveller and physician Engelbert Kaempfer. Kaempfer, who in the manner of his time, freely intermingled his German texts with Latin phrases, words and sentences, sometimes created abbreviations that combined elements from both languages. For example an often used abbreviations is ō-ʃ , standing for the German word *nichts*; this Kaempfer made up from the then established abbreviation for the Latin *non* ō and the final s ʃ of the German *nichts*.

Other abbreviations used in Kaempfer's manuscripts and diaries are

das *ß* , der *∿* , die *∿* , et *ə̃* und *ʌ* , links *ls* , or oder *∿* .

Printing did not eliminate the need for such iconographic aids. Many of the above abbreviation were taken over since, to begin with, printers tried to imitate the handwritten book as closely as possible. But even today we use a large number of iconic symbols such as for example:

£, $, %, &, , #, @, [,], <, >, /, +, =, or *; and punctuation marks like ?, !, :, .

Representation of numerals

As we have seen in the case of abbreviations, even fully phonetic writing systems do not make iconography obsolete. This is particularly true when it comes to the representation of numerals.

Already in ancient Egypt seven special signs were set aside to denote numerals. When written together to form a single number, they were placed in descending order of magnitude. Multiples of each sign were indicated by repetition (Davies, 1987).

In pre-Columbian Central America writing has always been closely connected with the creation and the development of a sophisticated almanac based on a high level of mathematical and astronomical knowledge (Robinson, 1995). This calendar was made up of two cycles operating concurrently. One cycle, the sacred year of 260 days, determined the pattern of ceremonial life. It was formed by joining 20 day names to the numbers 1 to 13, which were represented by iconographic glyphs. A 365-day cycle of eighteen 20-day months ran concurrently. To designate a particular day, the position in both cycles would be indicated. The combined system (which did not repeat a single date) divided time into self-contained (52 year) cycles, with the possibility that the end of each cycle could spell the end of the known world if special ritualistic precautions were not observed. To indicate dates beyond the span of 52 years, another, much larger cycle, was used. Dates from this cycle, called the Long Count, were inscribed in monuments. These dates recorded the number of days that had passed

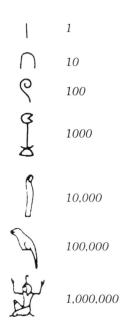

The seven special signs used for Egyptian numerals.

since a day in the year 3113 BC – and we are still able to correlated dates in this system with our own calendar.

The enabling agents in this complex system of calculations were three simple icons: a stylized shell for naught, a dot for one, and a bar for five. The position of the number symbols determined their value, with values increased by a factor of 20 from bottom to top in vertical columns. The first and lowest place has a value of one; the next, twenty; the next, four hundred; the next, eight thousand; and so on. In other words the Mayas did in fact use a binary code of astounding efficiency that allowed them to deal with periods of over five million years.

The Mayas used three icons to manipulate an already highly sophisticated binary code: a stylized shell for zero, a dot for one, and a bar for five.

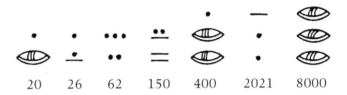

| 20 | 26 | 62 | 150 | 400 | 2021 | 8000 |

Special signs for numerals were also used by Sumerians and Babylonians between the later part of the 4th millenium BC and c. 75 AD (Walker, 1987). Linear B, one of the scripts of ancient Crete, which was deciphered by Michael Ventris in 1953, had special signs for units (short upright bar), tens (horizontal bars), hundreds (circles) and thousands (circles with rays). The number 1357 (i.e. 1000 plus 3 times 100 plus 5 plus 7) would look as follows (Chadwick, 1987)

The Sumerians and Babylonians combined a decimal (counting in tens) with a sexagesimal (counting in sixties) system of counting.

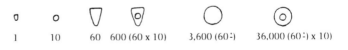

| 1 | 10 | 60 | 600 (60 x 10) | 3,600 (60²) | 36,000 (60²) x 10) |

In Cretan Linear B the number 1357 is written as follows:

Etruscan numerals are known to us from funeral inscriptions. They share certain peculiarities with Roman numerals, not only in appearance, but also the fact that the formation of numbers is achieved by subtraction (Bonfante,

1990). For example: CX = 90 (i.e. 100 minus 10 equals 90) or CMXCVL = 995 (i.e. 1000 minus 100 plus 100 minus 10 plus 50 minus 5 equals 995)

Another explanation for the formation of Roman numerals claims that they were originally representations of the human hand: I for one finger, V for a hand (of five fingers), X for two hands placed together at the wrist (twice five fingers). The concept of using finger signs has also been put forward as one possible explanation for the origin of the Ogham script which existed in parts of the Celtic speaking areas of the British islands between the 4th and 7th century AD. The Ogham alphabet consists of 20 letters represented by straight or diagonal strokes varying in number from 1 to 5; they are drawn or cut below, above or straight through a horizontal line. Vowels are shown by 1 to 5 notches (or strokes) on the central line. One theory suggests that this was originally a finger alphabet (hence the basic unit of five) which had been invented by the Druids as a private code for signalling.

Then there are, finally, our own 'Arabic' numerals: 0, 1, 2, 3, 4, 5, 6, 7, 8 and 9. They come in fact from India where their use developed in the first few centuries of the Christian era. A decimal system for whole numbers seems to have been known to the Indian astrologer Aryabhatta I (b. 476 AD). This system reached Mesopotamia around 670 where the Nestorian bishop Severus Sebokht praised it as being superior to that used by the Greeks. Within a hundred years after the death of the Prophet Muhammad (632 AD), the founder of Islam, Muslim influence extended over northern Africa, much of Spain, and eastwards as far as the borders of China. As a result of this expansion Muslims began to acquire foreign learning, and by the time of the Caliph al-Mansur (d. 775), Indian and Persian astronomical texts were translated into Arabic – much of this new knowledge was in turn brought to Muslim Spain.

¦	I	1
/\	V	5
×	X	10
↑	L.	50
(✳	C	100

Examples of Etruscan, Roman and Arabic numerals.

The twenty letters of the Ogham alphabet are (like the Runic alphabet) divided into four 'family' groups, each group consisting of five letters; this has led to speculation that the Oghams were originally a secret finger alphabet invented by the Druids.

Music notation

Notation acts as an aid to the memory of heard or imagined musical sound, and it also provides a set of visual instructions for the performance of music. There are basically two types of notation: phonetic symbols (words,

Ogham inscription from Scotland. The serpent and Z rod, and the crescent and V rod are Pictish and of enigmatic meaning; c. 8th century AD.

syllables, letters, numbers) and graphic signs (curves, lines, dots, signs depicting what were perhaps once hand signals, and neumes). Notation can also be used to form a drum and dance language, and in various branches of therapy.

Means of transcribing musical sound was probably known in Egypt as early as the 3rd millenium BC, definite recognisable notations were used in China and Japan from the 10th century onwards. Written notations exist in the musical culture of the Middle East, India, Southeast Asia and in the Far East.

In Europe staff notation has its roots in the neumatic notation of plainchant and secular song of the 9th to 12th centuries. Neumes, graphic signs indicating rise and fall of the voice, probably go back to signs devised by Greek and Roman grammarians for the guidance of declamation: i.e. / for *acutus* (high voice) \ for *gravis* (low) and ∧ for *circumflexus* (falling). The transfer of these signs into music notation took many different regional forms. At first just a memory aid for singers who knew words and melody by heart, later developments allowed sight-reading. More about music and dance notation appears in Chapters 8 and 9.

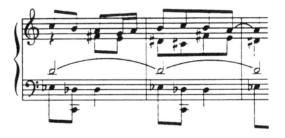

The primary elements of musical sound are pitch (location of musical sound on the scale), duration (rhythm, tempo, etc.), timbre or tone colour, and volume. A later refinement in representing musical sound was the use of horizonal lines as a grid.

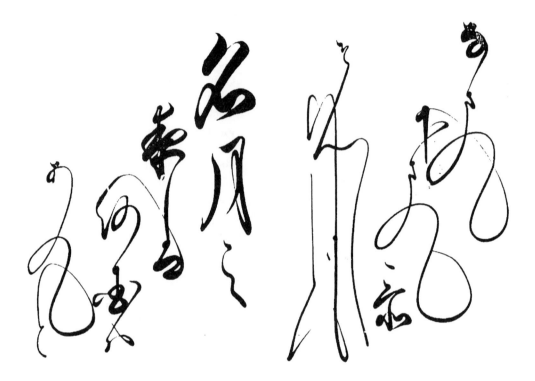

Having no script of their own, the Japanese adopted Chinese characters
together with Buddhism in the early part of the first Christian millenium.
But the Chinese script is ill suited to express the words and structure of
the Japanese language, and between the 8th and 10th centuries two
syllabic writing systems evolved. One of them, hiragana, was derived
from cursive forms of (whole) Chinese characters. During the Heian
period (794-1185 AD) hiragana, also called 'women's calligraphy', was
widely used by women authors for the writing of novels.

An example of the imaginative, and often quite extravagant way in which
cursive hiragana could be used by accomplished female calligraphers,
giving it iconographic rather than literary connotation.

CHAPTER 3

Iconography in calligraphy, religion and art

あ	*a*	*The conventional hiragana syllabary.*
い	*i*	
う	*u*	
え	*e*	
お	*o*	
か	*ka*	
き	*ki*	
く	*ku*	
け	*ke*	

In Zen Buddhism the fundamental forms of the universe can be represented by the square (man and his house on earth), the triangle (the fixed laws of nature) and the circle (the infinite and heaven). Other interpretations see the three symbols as representing various schools of Buddhist teaching, with the circle standing for Zen. Together they express the unity of all realms within the Buddha and as such play a prominent role in Zen calligraphy.

Iconography is an active element within the realm of calligraphy. Calligraphy depends largely on direct impact; it communicates, not only through the text, but – even more so – through the visual appearance of individual letters and the impression produced by the whole page. In China, and in the countries of the Far East, which for almost two millennia have been under the cultural influence of mainland China, the ability to write a good calligraphic hand has in many ways always been more important than the actual contents of the text itself. Calligraphy, it is thought, reflects the writer's inner self, it acts as a mirror of his (or her) character. In 10th century Japan, when courtly life revolved largely around the composition of poems, and a leisurely appreciation of music, calligraphy was an essential part of a woman's sexual attraction which could grant her upwards mobility – marriage into family more distinguished than her own.

In some eastern traditions there is also a special link between iconography, calligraphy and esoteric religious teaching. Japanese followers of Zen Buddhism use calligraphy not only to communicate their own personal state of enlightenment, but also as a means of teaching

From the 7th century onwards siddham letters (a form of writing derived from the Indian Gupta script) were used by some Chinese Buddhists for the representation of 'seed syllables' within sacred diagrams (mantras), each letter personifying a different cosmic force of the Buddha (or Bodhisattva). The four syllables shown are (from left to right) are: ha, representing Ksitigarbha Bodhisattva, the Bodhisattva of the Underworld and the patron of gamblers, travellers, lost causes and the dead; yu, representing Maitreya Bodhisattva, the Buddha of the future; sa, Avalokitesvara Bodhisattva, the Bodhisattva of great compassion; and mam, Manjusri Bodhisattva, the Bodhisattva of wisdom, learning and enlightenment.

essential parts of their philosophy. On the other hand,
Chinese siddham calligraphy, which has special connections
with a certain branch of Buddhist thought, uses individual
letters of the siddham script to represent different aspects of
the Buddha or Bodhisattva. As such they become endowed
with magic powers, and contemplation of these so-called
'seed syllables' unites the devotee with the divine (Gaur,
1994).

For a number of reasons, calligraphy can sometimes take
on highly eccentric iconographic forms. Buddhism and the
Chinese script reached Korea in the early part of the first
Christian millenium. Since then Korean calligraphy has for
centuries faithfully, and with great discipline, followed
Chinese role models. In the later part of the 19th century,
however, changes occurred which permitted the appearance
of more indigenous and at times also highly individual
elements.

Islamic calligraphy is based on the Koran and the Arabic
language, both thought to be direct gifts of God to the
Prophet Muhammad and his people. Because of the divine
origin of the Koranic message (and the medium used for its
communication) the Arabic script underwent (between the
7th and the 10th centuries) some far reaching and rapid
reforms. The result was a highly sophisticated and
disciplined form of calligraphy.

Generally, Islam is thought to be adverse to the
representation of living forms but within the realm of

One of a set of 19th century
munjado panels from Korea.
Each panel consists of one
Chinese character
representing one of the eight
virtues of the Confucian
classics all executed in a
highly unusual style of
calligraphy. This character,
written in the form of a
shrimp, stands for 'loyalty'.

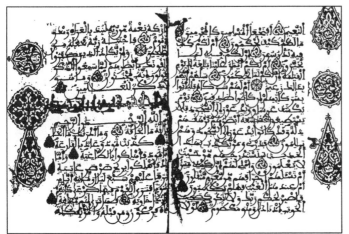

Opening of a Koran written
in Morocco in the Maghribi
(Western) style of
calligraphy with chapter
headings in Kufic, 1568 AD.
The surah headings and the
division between verses,
chapter headings and also the
margin of individual pages
provide opportunity for
various forms of
(traditional) ornamentation:
arabesques, palmetts,
rosettes, stellar medallions,
or some highly stylized 'tree
of life' symbols. The icon
becomes a punctuation mark
and a means of drawing
attention to important
divisions in the text.

Two lines of ornamental floriated Kufic (the final lines of letters take the shape of flowers) from a manuscript now in the Topkapi Museum in Istanbul.

The three Arabic letters – aliph, lam and nun-written in Taus, the 'peacock script'. Other such scripts existed and were known under names like 'bride's tresses' or 'flame script'.

calligraphy certain variations and concessions became possible. Kufic, the script used for writing the Koran, began to attract a number of non-figurative iconographic decorations for the use of title-pages or to mark chapter headings and verse divisions.

Eventually the letters themselves could incorporate ornamental shapes: foliated, knotted, plaited or animated. Individual characters could take the form of animals, human heads or figures (Safadi, 1978); though this was a practise frowned upon by the orthodox. Whole phrases and invocations, especially the *basmalah* (the sacred formula 'in the Name of God, the Compassionate, the Merciful', which is widely used before chapter openings in the Koran) are often written in various shapes: a particular animal, a bird (drinking from the fountain of Koranic knowledge), an architectural feature (such as a mosque) or a lamp (the divine light which flows from the Koran).

A short Arabic text written in square Kufic in the form of a mosque.

Hebrew, which has no definite calligraphic traditions, and a similar reluctance to represent living forms, developed a method by which the notes to the masoretic texts of the Bible could be written in micrographic script in various shapes (dragons, animals, birds, plants, biblical figures),

either at the bottom or in the margin of the page, or they could fill a whole page and be fashioned into iconic images especially connected with Jewish thought.

Masoretic notes could be used to create iconographic representations in a number of different forms.

Western medieval manuscripts include a wealth of iconographic devices. These appear as ornamentations within the text, in the richly coloured carpet pages or as a means to give prominence and distinction to the all important initials. The treatment of initials is an essential feature of western calligraphy, a trend which survived the invention of printing in the 15th century. Initials can be simple line drawings in black and white; they can make a point through the use of colour; they can incorporate abstract patterns, religious motifs, naturalistic or monstrously shaped animals, architectural forms, human beings, narrative episodes, or the portraits of biblical or historical personages. Initials can act as a visual introduction to the theme of the text or include images especially related to Christian thought.

Page from the Lindisfarne Gospels (c. 698 AD); the elaborate initial M in 'Marcus' includes elongated animal forms.

After the 15th century iconographic elements were used by the writing masters who (in order to compete with the new craft of printing) wanted to propagate their particular style, and their much prized virtuosity in using the pen, in order to sell their copy-books and attract fee-paying pupils. The images thus created can relate to the text, to iconographic fashions of the day or simply aim at dazzling the onlooker.

With the advent of printing in the 15th century the need for professional copyists declined, but some enterprising scribes turned themselves into writing masters, using the new invention to publish copy-books which propagated their own style. Competition was keen and individual masters tried to demonstrate their skill, not only by the formation of sometimes quite fanciful letter forms, but also by demonstrating their ability to create patterns and figures without lifting the pen from the page. From Edward Cocker's copy-book The Pen's Triumph, being a Copy-Book containing a Variety of Examples of all Hands, *published in London in 1660.*

An invocation in Persian, written in Arabic script, to the Prophet Muhammad, in the shape of two horses.

Another device to increase the iconographic impact of writing are calligrams, text-pictures, where the shape of the picture is determined by the subject of the text. The term itself was first used by the French poet Guillaume Apollinaire (1880-1918) to describe his own work. However, the convention itself goes back to at least the 4th century BC when the Greek poet Simias wrote poems in various iconographic shapes. Christian Europe continued this tradition (prayers written in the form of a cross) and, in recent times, calligrams have again been favoured by a number of modern poets (Dylan Thomas, Hans Arp), and also by some contemporary calligraphers.

Hela Basu's (d. 1980) interpretation of Edwin Muir's poem The Wheel *is written in the shape of a wheel which also serves as a clock telling time.*

Portrait of the Japanese Haiku poet Kyokusui (d. 1720 AD) with one of his poems; portrait and poem are written in a flowering cursive style.

In the opinion of the German calligrapher and book-artist Hans-Joachim Burgert (b. 1928) letter forms, and the arrangement of words in a printed text, should be enriched by a symbiosis between visual symbols and meaning. In consequence, some of his most invocative calligraphic compositions are often hardly legible. The text here reproduced is from Genesis 1:31 and reads 'Und Gott sah alles was er gemacht hatte und siehe es war sehr gut'.

The 20th century has seen another interesting development. While an increasing number of eastern calligraphers have studied at western universities and art schools, western artists too have become more aware of eastern attitudes and eastern concepts of art. In consequence a new form of symbiotic calligraphy has arisen. Some western calligraphers have begun to shape texts into icons which either intensify the meaning of the written words or communicate independently from them.

Iconography and secret communications

Since the icon does not 'spell out' meaning, but implies it, iconography has always been well suited for communications between groups living beyond the normal confines of society: special social classes, secret societies, esoteric religious communities and those operating outside the law. There is, of course, also the question of vested interests.

Egyptian hieroglyphic texts, for example, could well have been written by using only the 24 single consonant signs the Egyptians had already brought into use. But in ancient

Egypt scribes formed a highly privileged class. They were exempt from taxation and, in a country where everybody could be called upon to perform manual labour, they alone were not expected to work outside their profession. They had thus little interest in making writing an easily accessible craft.

Until quite recently, the Batak medicine men of Sumatra used to compile private note books which contained the sum total of their long apprenticeship and training. Written in the form of short personal notes, and furnished with enigmatic iconographic illustrations, such note books were intelligible only to those who had originally composed them. This exclusiveness of knowledge increased the power of the medicine man, and in times of tribal warfare the little note book, acting rather like a badge of office, could ensure him safe passage through hostile territory (Gaur, 1979).

Example of a Batak pustaha *(from the Sanskrit* pustaka *– book) made of long strips of bark folded accordion-wise.*

In a similar way the Moso script of the Naxi people of south-western China seems to consist entirely of iconographic drawings. Moso texts are in fact a form of memory aid and can be 'read' only by the hereditary Naxi priests who train their first born sons to memorise the

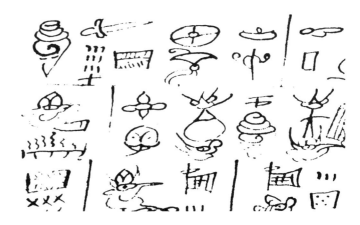

Moso invocations and prayers of the Naxi people of south-western China, 19th century.

sacred and ritual texts to interpret them with the aid of written symbols.

Among the Uyangas of Nigeria, members of the Nsibidi secret society use a special set of signs for communication and probably also as a means of magic. The origin of this so-called Nsibidi script, which came to public attention only in the 20th century, is still unknown, but there exists a charming local legend that describes how the Nsibidi learned it from the baboons who came to sit round their camp fires.

Within our own sphere of experience comes another group which by necessity operates outside acceptable social norms. These are the graffiti artists who deface (or decorate – depending on how one looks at it) buildings, vehicles, and even, at considerable risk to themselves, such dangerously inaccessible places as the walls alongside railway lines or underground tracks. Graffiti is mainly an urban art form; there are at present in cities like London or New York groups of practitioners who centre around a 'teacher' and his style. Graffiti uses a variety of letter forms, sometimes plain capitals strung together without any definite (readable) meaning, sometimes barely legible cursive forms (creating an image), sometimes purposely obscured characters and abbreviations. Like an icon, graffiti appeals directly; it is not an inscription.

Examples of the secret Nsibidi iconography which reads from top to bottom:
(1) A man and a woman sleeping together on a bed; it is very hot and they put their arms outside. The short strokes at the bottom of the picture sign represent the legs of the bed.
(2) A boy had a girl as his friend until they both grew up. Then he married her and they lived together and made their bed with pillows for the feet, and pillows for the head.
(3) A man and his friend went to town to find two girls; one found a girl and took her home, the other could not find a girl and the two parted company.

Example of graffiti photographed in London in 1993. Graffiti has a long history and was especially popular in ancient Rome – 1600 examples have been found in the ruins of Pompeii alone.

Belief in the special significance of Hebrew letters is central to cabbalistic Hebrew thought. Certain esoteric knowledge can be expressed and communicated by seemingly unintelligible combinations of letters and the use of their numerical value. Letters become icons that have meaning

Book of Adam and Raziel; *Amsterdam, 1701. The text is written in square Hebrew script intermixed with* kalmosin. *In cabbalistic literature* kalmosin *are also known as* ketav ainayim *(eye-writing) because the individual characters are composed of lines and small circles – this in turn has encouraged some extravagant speculation about possible connections with the (much older) cuneiform script of ancient Mesopotamia.*

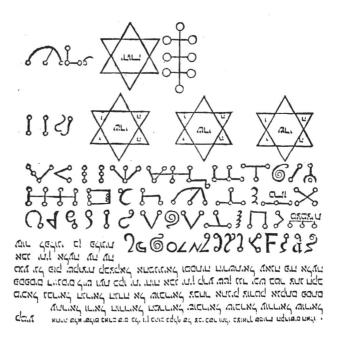

only to a particular group which shares certain esoteric knowledge. Thus the Torah can be read simply as a text written in Hebrew script, but there exists another, mystical reading, which perceives the Torah as composed of the secret names of God.

To the realm of practical Kabbalah belong the *kalmosin*, the angelic pens, thought to have been created by archangels such as Metatron, Michael, Gabriel and Raphael. Sometimes such letters are used in a text otherwise written in normal Hebrew for representing the Tetragrammaton or the divine names Shaddai and Elohim.

Then there are finally those sections of society which, either by birth or from choice, function, at least in part,

outside conventional society: Freemasons, criminals, terrorists, thieves and all types of social drop-outs. They need, by necessity, a form of communication, intelligible only to themselves, and to this end iconography is ideally suited. Into this category fall the rogues' codes, hobo-signs and *Gaunerzeichen* which mark victims, advertise insufficiently protected property, or give warning to members of the same group. In western Europe such signs have been documented since the 16th century; at the end of the last century some 17,000 different iconographic symbols were identified (Streicher, 1928). Paul Scott, in his *Division of the Spoils*, describes how, during the disturbances that followed the partition of India, railway compartments carrying Muslims were sometimes secretly marked with tiny crescent moons and thereby singled out for attack.

Gipsy and hobo-signs fall into this area, but the information they store is mostly designed to help and advise and to prevent other travelling members of the community from coming into unnecessary conflict with the law.

Some American hobo-signs

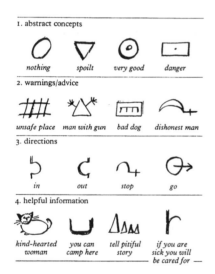

1. abstract concepts

nothing · spoilt · very good · danger

2. warnings/advice

unsafe place · man with gun · bad dog · dishonest man

3. directions

in · out · stop · go

4. helpful information

kind-hearted woman · you can camp here · tell pitiful story · if you are sick you will be cared for —

Iconography in religion and art

Though we cannot be absolutely certain about the meaning and purpose of prehistoric rock paintings and engravings, much supports the theory that they might (at least in part) have been a form of religious art. We can derive strength for this supposition by the way iconographic representations have been used in later, historic, times among such groups as the Aborigines of Australian, in Polynesia, by groups of American Indians, in contemporary tribal art forms of Africa and Asia, and indeed also in western folklore. It is

probably in the realm of religion and magic that both art, and a need for using iconography as a means of information storage and communication, first arose. Iconography (abstract and figurative) served to support oral traditions and as such it survived in memory aids, pictographic writing, and to some extent also within the perimeter of phonetic scripts. The main difference between iconography and art (as we now understand it) lies in the fact that iconographic designs and images express communal, sometimes archetypal feelings. They follow certain instinctive conventions and, like writing, make definite statements. The icon has power in itself; art simply justifies its own existence.

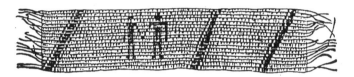

Wampum belt from North America.

Iconography plays an important role in tribal life. We have already mentioned wampum belts – woven pieces of cloth decorated with shells. Those used by the Iroquois of North America combine pattern and colour to transmit messages. They can convey meaning, either by geometrical designs, or by the use of pictorial representations, or both: a black belt with a tomahawk in red is a declaration of war; two hands on a white background stand for a peace treaty, and so on.

The Thunderbird of the North American Alogonquin Indians.

Shamanistic cultures often use iconographic representations of their totem which can act as ancestor and guardian spirit. Among American Indians clan symbols, such as for example the turtle, can be seen carved on pipes (Iroquois), or painted on caribou skin coats (Naskapi). Important spirits like the Underwater Panthers are depicted on bags or drums related to the Midewiwin, a Shamanistic Great Lake cult. Among the Alogonquin Indians especially potent spirits are the Thunderbirds who reside in the Upper

World and guarantee fertility by the creation of clouds and rain (King, 1982).

The Hopi Indians of north-east Arizona have annual ceremonies where men impersonate *kachinas,* supernatural beings who reside on the San Francisco Peaks, by dancing masked in the village Plaza. The number of *kachinas* is large, c. 266 altogether, and in the dance ceremony each is represented by a different mask. As an additional means of identification special symbols are painted on the cheek and forehead of each mask (Colton, 1949).

Iconography is also a vital element of tribal Africa. But whereas three dimensional objects (greatly prized by 19th century European collectors) belong mainly into the more secretive realm of religious ritual, iconographic decorations appear quite openly on house-posts, doors, clothes, harnesses, mats and on a large number of useful everyday objects (Duerden, 1974). But pure decoration is hardly ever the icons sole purpose. By representing elements of tribal life and culture such decorations can also act as protective amulets.

Icons used for decorating (and identifying) the kachina masks. Each mark has a definite meaning, the ones here shown read, from top to bottom: blossom, cactus flower, warrior's mark, mark of some office, phallus/ reproduction, and friendship.

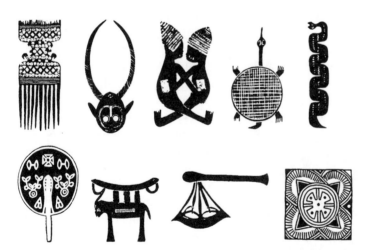

African iconography is closely related to religion and ritual, and to the idea of kingship. There are some recurring symbols such as the chieftain's chair, the turtle, horned masks, the lizard, snakes, birds, twins, and so forth, as well as abstract patterns.

Hinduism uses a vast iconographic vocabulary. There are the attributes and emblems associated with the many different deities of the Hindu pantheon. The trident of Shiva, stylised representations of the breasts or the eyes of Kali, the noose by which Yama, the ruler of the dead ensnares his

In the Mysore area childless women erect Nagastones on a platform around a tree and worship them once a year at a special festival.

Nandi, the bull, who is the vehicle for the God Shiva, with the Shivalingam, representing the God, on his back.

The lingam and the yoni (male and female principles).

The elephant goad serves as emblem for several Hindu deities.

The 'Noose of Time' used by Yama, the God of the Dead.

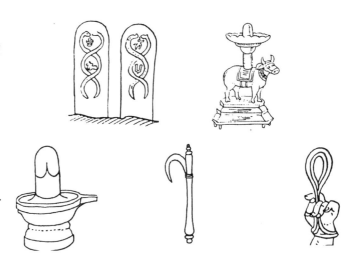

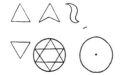

Trikona, geometrical symbols which in Hinduism represent the unapproachable Divine. Upward pointing triangles, vertical arrows and flames denote development, fire and the lingam of Shiva; downwards pointing ones, nature; the yoni is shown by the circle with the central point being the root of the lingam; two triangles penetrating each other represent Purusha (the cosmic man) and Prakriti (nature/female); when united they form a star which indicates equilibrium.

victims, the elephant goad which is the emblem of a large number of deities (Ganesha, Indra, Skanda, Shiva, Agni, Brahma). Female symbols such as the *yoni* (vulva) are thought to represent the goddess, the *lingam* (phallus) can stand for Shiva, and the combination of both signifies sexual union and auspiciousness. There are, in addition, the traditional vehicles (animals used for transport) of the gods, like the bull (Nandi) of Shiva or the mythical Garuda bird of Vishnu. And there are further the innumerable local deities whose cult and representation can incorporate many, sometimes non-orthodox and pre-Hindu, iconic elements: the mother goddesses of the south and their symbols, or the snakes (Nagas) which are generally considered symbols of fertility.

Abstract symbols and patterns play an important role in orthodox Hinduism, Tantrism, Tantric Buddhism (which mixes elements of both with manifestations of older beliefs) and also in daily life and in folklore, from the simple red dot on the forehand worn by married women to denote their auspicious state, to the highly complex sectarian marks which Vaishnavas, Shaivites and Shaktas (devotees of the goddess) paint on their foreheads, to purely geometrical symbols representing, on the one hand, the unapproachable nature of the divine, while at the same time acting as an aid to meditation (Stutley, 1985).

To the sphere of Tantric Hinduism, as well as certain Buddhist traditions, belong special mystical or symbolic geometrical diagrams (*mandalas* or *yantras*) which indicate the basic energies of the world as represented by the deities. Tantric Hinduism and Tibetan Buddhism use them as an aid to worship and meditation but also as a cosmographic ground plan for temple architecture. Every measure in the design is determined by specific laws of proportion to put the structure in harmony with the mystical numerical basis of the universe and of time itself (Stutley, 1985). The symbolism is both sexual and cosmological, the triangle for the male, the circle and the lotus for the female principle (the Tibetan prayer *om mani padme hum* translates as 'the jewel is truly in the lotus'). In Chinese Daoism the circle stands for heaven, the square for the earth, and the complete cosmic circle is shown as comprising two complementary forces – *yang* (male) and *yin* (female).

This complex and often highly esoteric use of patterns appears in more simplified form in Hindu folklore. It is, for example, a common practise amongst women to paint auspicious patterns called *rangolis* or *alpanas* with white rice flour outside the entrance of their houses at the beginning of each day. Such patterns can also be used to decorate thresholds, courtyards, ceremonial platforms and the floor of the living area, or at least that of the *puja* (worship) room. Elaborate ones will be made for festive occasions (like a wedding), simpler ones suffice for daily use.

The Shrichakra Yantra, *a meditation diagram used in Tantric Hinduism, represents the union of Shiva and Shakti. Inside the outer frame are concentric circles and stylized lotus petals. Within these circles nine grades of revelation are shown by five downwards pointing (female) triangles, interlocked with four upwards pointing (male) triangles. The empty centre point (bindu) represents the Absolute that cannot be visualized.*

In Chinese Daoism the cosmic circle comprises two complementary forces – male (yang) and female (yin) which are represented by the eight trigrams made of a variant combination of single lines.

Examples of alpanas *or* rangolis, *auspicious designs for welcoming deities, which are made with rice flour each morning by Hindu women outside the home.*

Rajasthani village women paint small coloured designs (in brown, red, blue, green and yellow) to decorate the wall beside the entrance of their houses whenever a son is born in order to attract good fortune and advertise the happy event. These signs vary from traditional ones such as highly stylised peacocks, the tree of life, mating birds, the fan, to purely abstract ones. Modern elements (like, for example, the picture of a locomotive) will sometimes make an appearance, showing both the resilience and adaptability of rural iconography (Gaur, 1980).

Examples of the coloured designs Rajasthani village women paint beside the house entrance whenever a son is born. Some designs are no longer clearly identifiable; others, like the two here shown, constitute archetypal and universally used icons: the tree of life, the two mating birds, the pitcher containing the water of life.

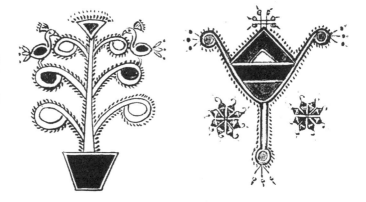

Village life, village rituals and village industries have their own way of using iconography. Apart from house decorations there are the motifs and designs used by carpet makers and weavers all over the world which can communicate important local information. The Limbu weavers of eastern Nepal, for example, use, besides a variety of no longer explainable abstract patterns, two special motifs: the elephant trunk and the *mandir*, which imitates the shape of the Nepalese temple. The Rai, another local tribe, embroider their shawls with diamond-shaped patterns which they call *kothi* (houses). The traditional jackets worn

*Left: Two often used Nepalese (Limbu) weaving patterns: the temple (*mandir) *alternating with the elephant trunk (*hatti).

Right: The embroidery at the back of the traditional jackets worn by Rai men indicate the tribe to which a man belongs (Dunsmore, 1993).

by Rai men have a special type of embroidery at the back of
the garment showing to which local tribe a man belongs
(Dunsmore, 1993).

Orthodox Buddhism makes use of iconography in its own
way. Originally the Buddha himself was never represented in
visual form but only indicated through certain attributes:
his footprints, the *chakra* (the wheel of law/life/dharma), or
perhaps the 'Three Gems' (*triratna*) which consist of three
interconnecting wheels representing the Buddha, the Law
and the Sangha (Buddhist community).

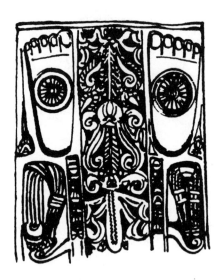

The footprints of the Buddha.

The lotus symbol.

The 'Three Gems'.

Christianity, despite early ionoclastic tendencies (an
inheritance of its Hebraic ancestry and a reaction against
the cult of idols as practised by the pagan religions it tried to
replace) has over the centuries developed a vast
iconographic vocabulary. Christ himself can be represented
by various, well defined iconic symbols: the cross, the
monogram IHS, the lamb (St John's 'lamb of God who takes
away the sins of the world'), a fish (the letters for the Greek
word 'fish' are the initial letters of the five words 'Jesus

The nails, a symbol of the crucifixion of Christ.

The key of St Peter (St Matthews 16:19 'I will give unto thee the keys to the kingdom of heaven').

The fish as symbol of Christ.

The dragon as a symbol of the devil, the enemy of God.

The scorpion which can stand for Judas.

The shell, now associated with St James and pilgrimage but originally a symbol of Venus.

Christ God's Son Saviour'); or by the instruments of his passion such as the nails or the crown of thorns. Like some Hindu deities certain Evangelists can be shown with, or represented by, their special animals (the lion of St Mark, the ox of St Luke, the eagle of St John). Saints too have their attributes, usually connected with their legendary life stories: the organ for St Celia, the keys (of the kingdom of heaven) for St Peter, or the axe for St John the Baptist (Ferguson, 1954).

There is also a whole range of 'negative' Christian iconographic symbols associated with the devil and Christ's adversaries. A cross turned upside down plays an important part in satanic rituals, as does the five pointed star; the devil can be shown by a dragon, a fly or a snake (the form in which he appeared in Paradise); the scorpion can serve as a representation of Judas. There are furthermore the large number of symbols which have found their way into Christian iconography from other beliefs such as the already mentioned Egyptian *ankh*, Easter eggs and their decorations; or the shell, an attribute of pilgrimage specially connected with San Diago de Compostella in northern Spain but much earlier on associated with the goddess Venus, or the grape vine, which symbolizes the Last Supper and Christ's blood, but comes originally from the cult of Dionysos.

Iconography and art

On a purely secular level the term iconography has historically been associated with an artist's use of imagery in a particular work. The first iconographic study of this kind was made by Cesare Ripa in his *Iconologia* (published 1593). This is a catalogue of emblems and symbols collected from antique literature and translated into pictorial terms for the use of artists. In the 18th century such iconographic studies consisted mainly of a classification of subjects and motifs in early monuments. In the 19th century these studies divorced themselves from archaeology and concentrated primarily on religious symbols in Christian art; in fact for some time iconography became more or less identified with Christian symbols, pictures and the statues of saints. It was only in the more open minded and liberal 20th century that secular and classical European art, and

eventually also the iconographic aspects of eastern religion and art were included.

Western painters have, however, quite independently from such fashions of research, used and developed their own iconographic vocabulary to give deeper meaning to their work. The painter Joan Miro (b. 1893) has, for example, created a whole thesaurus of furled, rounded and hooked devices which appear again and again in his paintings. Picasso (b. 1881) often uses the motifs of the bullfight as a central theme, an idea which he brought to culmination in his famous *Guernica*. Ben Nicholson (b. 1894) favours circles and squares in his paintings in a manner reminiscent of Zen calligraphers, and Jean Cocteau's (b. 1891) frescoes in the Chapel of St Pierre in Villefranche are hauntingly dominated by highly stylized eyes and the motif of the fish.

PART 2

Iconography in the computer age

The computer brings advantages to symbol systems in terms of efficiency and availability but inevitably some elements of standardisation as well. Iconography for special needs, sight and hearing impairment as well as music and movement notation, illustrate these developments. Designers' responsibilities are stressed as well as the specific requirements of users, while multi-media, multi-lingual and cross-cultural icons point the way to the future.

Rosemary Sassoon

CHAPTER 4

Extending the subject of iconography

Anything can be given meaning and used as an iconography. This computer-generated set of symbols designed by Gunnlaugur SE Briem was an exercise, with no special use in mind – but it has endless possibilities.

Before words there were sounds and intonation, before writing there were symbols. Speech splintered into different languages, different symbols developed into various writing systems. Writing systems separated into the symbolic and the phonetic, but symbolic iconographies persisted from earliest writing to the present day. Only the symbols changed. As the computer replaces the the pen and the brush, so iconography, with today's symbols, prepares for tomorrow.

Definitions

A good way of starting this part of the book is to define some of the terms to be used, then perhaps to dispel some of the preconceptions that surround them. An icon (or ikon), according to the Oxford Companion to the English Language, is a 16th century term derived through Latin from the Greek eikon meaning likeness or image.

If something is iconic, according to the same source, it represents something else in a conventional way, as with features on a map (roads, bridges, etc.) or, somewhat surprisingly, onomatopoeic words as, for example 'kersplat' and 'kapow' in US comic books standing for the impact of a fall and a blow. The word iconography provided four different definitions:

1 The study of imagery in the visual arts...
2 An archetypal image...
3 A person regarded as embodying a certain quality, style or attitude in a distinctive, often charismatic way...
4 A stylized symbol, especially in computing...

It is this last definition which is most relevant to this part of the book. The nearest definition of iconography or iconographies that would help to describe the other contents of this book was 'symbolic representation through... [a] system of iconic representation'. That is why we have used the term symbols as part of the title; it might be better understood.

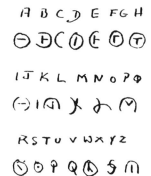

A schoolboy's secret code.

Symbols are, according to the same publication:

1 Something that represents something else. (The example given is of a heart pierced by an arrow as standing for romantic love.) The definition continues: 'In principle anything can symbolise anything else, either temporarily or permanently, especially something concrete or material to represent something abstract or non-material. An association can be formed between them, for example a river symbolising the flow of life – a circle symbolising completion – a light symbolising God.'

2 A mark, figure, character, etc. alone or in combination that serves to designate something else, such as x used in algebra to stand for an unknown character, or the chemical formula O representing oxygen.

These definitions are certainly very close to my concept of an icon as a part of an iconography, so, if I dare to attempt a definition of an iconography, it is this: a symbol system designed to convey ideas independent of words and therefore of language. There can be a pictorial association between the sign and the idea but this is not essential. I hope that this definition will be justified by what follows.

Some preconceptions to be dispelled

It is important to be precise with terminology. Take for example hieroglyphics. As a system, hieroglyphics do not correspond precisely with iconographies as they contained phonetic elements. Hieroglyphs are, however, more or less synonymous with icons. It is therefore correct to say that the principles of hieroglyphs have never been entirely replaced by the phonetic scripts.

Historically icons divide themselves into two:

1 symbols that were readily associated with objects, where the pictorial association is preserved

2 symbols which once had pictorial associations that have since vanished. Thence signs developed to have two uses: to indicate a syllable or hieroglyphically for an idea.

In countries where there is widespread illiteracy party symbols play a large part at election time. They appear on ballot papers where those who cannot produce a signature are allowed to vote with a thumbprint. A split in India's Congress party has left both sides contesting the right to use the instantly identifiable symbol of a hand.

The accepted context of an icon is a pictorial one, a picture with a conventional meaning that is easily understood. This, however, is only a small part of the subject – both in an historical perspective or a contemporary one. It is tempting to start out by saying that in order to work well an iconography must be universally recognisable. Icons throughout history have not necessarily been recognisable, even contemporaneously, and today recognition is certainly not a prerequisite of an icon, much less a complete iconography. For an iconography to be immediately comprehensible (or better still, recognisable, because that word presupposes cognition) it is dependent on a previous visual experience. This is patently not always possible. In other words, an iconography may need to be taught or, conversely, learned. Complex iconographies (in a typographic sense) have been designed for specific languages which previously had no written forms, such as Eskimo. The would-be reader could not have been prepared to decipher them by any previous visual experience.

Pitseolak: Pictures out of my life ᐱ�ᐳᒧᑲ ᐅᖕᑲᑐᐊᑲ ᐃᓄᓕᐳᑕ ᐅᑐᒋᑲ

From Pitseolak: Pictures out of my Life. *OUP Toronto*

Even road signs, perhaps the most frequently used example of an internationally-recognised modern iconography, need to be learned. Some of them may be pictorially obvious, and others become so in context, but not all. They need to be memorised and are carefully examined (out of context) as a part of every driving test. Road signs, of course, introduce another dimension to icons – a meaningful frame or external shape. The difference between a circular frame for a mandatory sign or a triangular one for advisory ones is vital to the driver. There are historical precedents for the use of shapes, such as a cartouche in Egyptian hieroglyphs. Colour can add yet a further dimension. The colour conventions that denote contours on maps provides a familiar example. Even simpler is the concept of red for

danger – a universally recognisable icon in itself which needs no pictorial element.

An iconography can just as easily be a code designed to conceal the meaning of a message to all but a chosen few. All it requires is a glossary, whether for a group of small boys who have formed a secret club – or for more serious purposes. For example, the Sumerians, at least 4000 years ago, had an alternative word (icon) list to enable the scribal class to retain its exclusivity.

KAUDER IDEOGRAPHIC CHARACTER

Ten Commandments 1866

POLLARD SYLLABIC SCRIPT

Mk 1. 1–4 1938

KUOYÜ PHONETIC SCRIPT

Mk 1. 1–4 1958

During the 19th and early 20th centuries the missionaries developed various ideographic, syllabic and phonetic scripts. This work was intended mainly for the translation of the Bible into languages which had no written (or printed) form. As well as their primary use for religious purposes, this work has made a considerable contribution to the spread of literacy. Illustrated here: the Kauder ideographic characters for the Micmac language, Pollard syllabic script for the Miao in southwestern China and the Kyoyu phonetic script for the Amis language spoken in eastern Taiwan (Formosa). These illustrations come from Nida (1972), The Book of a Thousand Tongues. They are reproduced by courtesy of the publishers, The United Bible Societies. On page 65 there is an example of the Evans script for the Eskimo language used for non-religious purposes.

The opening pages of the Penguin edition of Androcles and the Lion, *published in 1962. This unique edition shows the Shaw alphabet with a parallel transcription in traditional orthography. It is easy to see the considerable savings in space that would result from the use of the new alphabet.*

ANDROCLES AND THE LION

PROLOGUE

Overture: forest sounds, roaring of lions, Christian hymn faintly.

A jungle path. A lion's roar, a melancholy suffering roar, comes from the jungle. It is repeated nearer. The lion limps from the jungle on three legs, holding up his right forepaw, in which a huge thorn sticks. He sits down and contemplates it. He licks it. He shakes it. He tries to extract it by scraping it along the ground, and hurts himself worse. He roars piteously. He licks it again. Tears drop from his eyes. He limps painfully off the path and lies down under the trees, exhausted with pain. Heaving a long sigh, like wind in a trombone, he goes to sleep.

Androcles and his wife Megaera come along the path. He is a small, thin, ridiculous little man who might be any age from thirty to fifty-five. He has sandy hair, watery compassionate blue eyes, sensitive nostrils, and a very presentable forehead; but his good points go no further: his arms and legs and back, though wiry of their kind, look shrivelled and starved. He carries a big bundle, is very poorly clad, and seems tired and hungry.

His wife is a rather handsome pampered slattern, well fed and in the prime of life. She has nothing to carry, and has a stout stick to help her along.

21

Kingsley Read, the designer of the 47 character 'Shaw Alphabet' wrote in 1974 that: 'George Bernard Shaw died convinced that a new alphabet was needed to enable people to write and read the language more efficiently. Read explained that Shaw sought a wholly new alphabet – 'to be used and taught concurrently with the old alphabet until one or the other proves the fitter to survive'. In his will it was implicit that the main object was to be 'saving of labour … a means of writing in the English language which will be more economical of the writer's time, of the paper and ink of the printer and of transport and storage'. The illustration above shows that indeed Shaw's alphabet was more economical to print, however, as a symbol system it has not stood the test of time.

The Lord's Prayer rendered in Kingsley Read's alphabet. The illustrations on this page appeared in Icographic, *number 7, 1974, and are reproduced here by permission of the editor, Patrick Wallis Burke.*

Extending the concept of an iconography

Many of the means of communication that we use in our daily life are iconic – only we do not necessarily recognise them as such. Take numerals for example. Anna Partington, who is a philologist, explains that quantity is interesting from the point of view of graphic representation: 'Because the (likely) original ideographic forms are still in use today; for in the context of calculation they are quicker and less space consuming to use than phonetic graphics. Early European and Mideast ideos feature similar stroke (line) and dot (circle) constructions. For example two appears as variants of || and ••. There are, however, some now redundant pictographic methods of recording quantities which combine identification of the quantified entity with quantity as in inventories. For example, a picture of two pottery jars (pithoi), could indicate a quantity of wine or oil in terms of the capacity of the two jars.' She adds that 'When ideographic representation was replaced by phonetic representation for the bulk of language, the individual alphabet signs were also used in some languages to denote quantity. This is an informative development; for changes in the number and order of letters in an alphabet can sometimes be traced by identifying the quantity a letter represented.'

Punctuation is another example. Punctuation represents the relationship between sentences or their parts. A comma represents a distinction but still a relationship within a sentence, whereas a full stops marks off one sentence from another. There are two variations of the full stop. A question mark indicates that the sentence asks a question. Then there is an exclamation mark. This is more often a comment by the writer than an indication of the nature of the sentence. This can also be extended to tie into the concept of using any symbol (or icon) to represent anything you wish. Van der Post (1984) provides an unusual example of how he uses an exclamation mark along with other

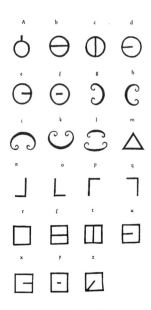

Geofroy Tory, in 1529, described Sir Thomas More's Utopia alphabet (above) as: 'Letters which we might call voluntary letters, made at one's pleasure, as are those which the makers of ciphers and decipherers drew in such shape and form as they chose, to compose new things which cannot be understood without knowing the alphabet of the said voluntary letters.' From Dover Publications Champs Fleury *(1962).*

Dental click Alveolar click Alveolal-palatal click Lateral click
From van der Post and Taylor, Testament to the Bushman *(1984)*

The McDonald trademark is recognised throughout the world. In China a huge illuminated sign looms over Tiananmen Square. It is shown here with its Chinese phonetic equivalent.

phonetic symbols to denote the clicks of the Bushman tongue for which, as he puts it, 'No conventional symbols suffice'.

Apart from those iconic usages already mentioned, there are many different sets of directional and instructional signs, trademarks and logos, signatures, nautical flags, etc. Take just one historical example – heraldry. Although Fox-Davies (1925) in the Complete Guide to Heraldry states that he 'hesitates to follow practically the whole of heraldic writers in the statement that it was the necessity for distinction in battle which accounted for the decoration of shields' undoubtedly that is one of the major original uses of this particular iconography. Extend that idea of identification in battle or elsewhere, and you might reach the iconography of clan plaids, which are by no means exclusive to Scotland. Extend that idea again and you might arrive at knitted gansies. These were fishermen's sweaters each knitted with exclusive family designs (mainly cable and other stitched patterns on the yoke). Apart from the decorative purpose of these designs, they were used to enable the identification of a drowned fisherman. The list is endless.

Heraldry is alive and flourishing in the computer age. These armorial bearings belong to the Worshipful Company of Information Technologists, the 100th Livery Company of the City of London. Their symbolism is interesting. Mercury the messenger appears on the crest, while stars symbolise the rapid dissemination of information, and a key represents data storage.

A less obvious use of the iconic principles within the phonetic/alphabetic scripts is this: we write letters but we read words. Words therefore become hieroglyphs or icons themselves. As an extension, in some cases and for some people, sentences, poems or whole works of literature (Shakespeare, for instance) or religious belief (the Koran) become icons in themselves.

Icons give direct communication, are not language

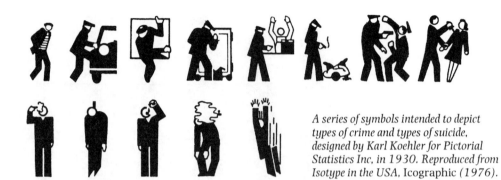

A series of symbols intended to depict types of crime and types of suicide, designed by Karl Koehler for Pictorial Statistics Inc, in 1930. Reproduced from Isotype in the USA, Icographic *(1976).*

specific and are basically non-verbal. As a complete writing system, iconographies (and here ideographic scripts, mainly but never wholly consisting of icons, such as Chinese, are included) can be cumbersome. By contrast, phonetic scripts (nowadays mostly alphabetic) are both language specific and verbal: but they are simple.

Learning from history

If we are to utilise the full scope of computer generated iconographies we would do well to study historic examples. We are fortunate to have access to, and interpreters and exponents of, perhaps the oldest iconography of all: that encompassed in Aboriginal art. Sutton (1988) explains, 'The formal simplicity of much Aboriginal art belies its embodiment of complex social mythic and ceremonial meanings. It often rests on the preference for cryptography and obliqueness demanded by a restricted economy of religious knowledge, the basis of so much power in traditional Aboriginal society'. Sutton compared Aboriginal art to European Impressionist art: 'While the impressionist painter sought to achieve something like a copy of a visual impression, the Aboriginal seeks to create reductive signs for the things represented.' He also tried to explain the various levels of interpretation of Aboriginal iconography. We are all, however, dependent on contemporary artists and elders for interpretation of the images that represent their ancient culture and religion, and who may designate the symbols with either deeper or less deep meaning than the original designers. These symbols have been handed down over millennia – and many rock drawings, a few thought to

This work was built on Otto Neurath's work with the Isotype (International System Of TYpographic Picture Education) team in Vienna in the late 1920s and 30s. Twyman, in the same issue of Icographic, *explains how Neurath saw the need to establish a set of conventions to make communication easier and more effective. He continues: 'The lasting influence of the Isotype Movement is probably seen most clearly in the field of graphic statistics'.*

date back to the stone age, are still visible and open for comparison and to interpretation. Sutton argues (from a European point of view): 'Simply knowing which objects in the world are denoted by which symbol certainly adds to the intelligibility of painting, sculpture or sand design. It also enables one to see how a myth and its pictorial representation are structurally related. Frequently, though, this is the only level at which any explanation of Aboriginal art objects is offered in explanations and publications. Aboriginal artists themselves seldom go very far beyond this representational aspect when talking about their work. This is partly because of religious restrictions on divulging knowledge ...'

The remarkable images of the aboriginal iconography make up a multi-level symbol system with a deep complexity of meaning. It is both an open and a closed system at the same time, its secrecy being not absolute but a continuum. In addition to knowing the basic symbols, an understanding of the role of colour, the narrative content, perhaps the sites involved in the dreaming depicted and the how the work of art relates to its community and religion are essential for deeper interpretation. The meanings of the symbols can vary according to the context and, even more significantly, with the level of knowledge of the viewer. As Pekarik puts it, in the preface to Sutton (1988): 'It was as if almost all of the human creative energy of a culture over tens of thousand of years old had been invested in the development of the society's spiritual, intellectual and social life. The paintings... were in fact the symbolic record of this achievement over the millennia'. No future iconography is likely to approach this level.

Monotype has developed a font based on interpretations of early southwest Native American rock art and pottery. It is called Artifact. Monotype's publicity states that: 'Documents will come alive when you use Artifact's unique icons and images from Native Navajo, Hopi and Zuni culture'.

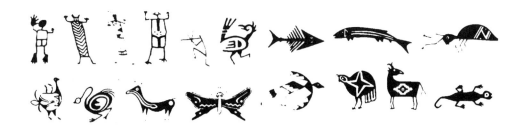

Building on the lessons of history

The history of the use of icons is vital in order for us fully to understand their flexibility and the concepts that govern their design and usage. We use them, consciously or unconsciously, throughout our lives – sometimes hand written but increasingly computer-generated. Some obvious usages are:

As a child before we can write

To make our mark on the world, whether a signature, a carving on a tree or graffiti on a wall

To communicate when we cannot do it any other way

To communicate with those whose language we cannot speak or when disabled

To prompt a narrative

To communicate with unknown prospective clients and to project our image

To put out information needing to be quickly assimilated where words would be too lengthy

To leave behind information for the future – perhaps in time capsules.

Fun fonts – Providence, Providence Dingbats and Big Cheese Light

a b c d e f g h i j k l m n o p q r s t u v w x y z

Today type founders are issuing what they term iconographies almost at the same rate as new typefaces. Some of these sets of symbols have distinct usages, for the preparation of holiday brochures for example, some have more frivolous usages, and some are no more than clip art to liven up the appearance of pages. While amusing, decorative, and useful in some senses, the proliferation of these images risks destroying the purpose for which they were produced. A host of ambiguous icons will only end up causing confusion.

In this part of the book practitioners, who use specific

Symbols from Agfa logos and symbol fonts

Signs for Argentinian flora. Reproduced from 'Signing system for an Argentinian new town' from Icographic *(1978). These symbols were part of a comprehensive scheme designed to a set of strict graphic rules that governed their development. The intention was, among several other criteria, to establish a symbol code that is readily understood by all levels of people in the area.*

iconographies in their daily life, provide a picture of the possibilities that are opening up for computer generated symbol systems. They explain the effects that the computer has had on their practices and their everyday work. But it is not only a matter of listing these usages and reading the sections specially written by those practitioners. At every point we need to consider the pre-computer stage and think seriously about what has had to be sacrificed in the pursuit of convenience. But it is more than that. Unless we make a conscious effort to understand the relationship between the hand-made icons and the computer-generated ones, then individuals may fail to grasp the opportunities in their own fields, and make the necessary related adjustments that will carry them to take advantage of the newest computer techniques.

For the sake of international communication some national individuality of detail may have to be sacrificed. In the interests of the common good some of the aspects of copyright that are still so jealously guarded will have to relax. As was said in the beginning – it is not always necessary for an iconography to be generally recognisable, and sometimes desirable that the opposite should be true, but in the international areas of special needs, uniformity is important. Unless, for example, as Yule writes on page 99, icons for the visually impaired are standardised advanced international interaction between blind scholars will be impeded. In other circumstances, copyrighted iconographies result in their usage being limited and users remain confined to small isolated groups. Publications in these systems will be uneconomic. Time will be wasted and expertise diluted by teachers and carers who may have to learn several symbol systems in the course of their work.

There is a further consideration and that concerns the freedom to develop variations from copyrighted iconographies. Charles Bliss (see also p81) was so determined to protect what he saw as the integrity of his Blissymbolics that, incorporated into his personal letter heading, is the following warning: 'The Blissymbolics and the books are copyright registered under the Berne Convention, the Copyright act of the USA and the universal Copyright Convention. ALL RIGHTS RESERVED. Infringers and

perverters have been and will be prosecuted anywhere to ensure uniformity as ONE WRITING FOR ONE WORLD. Caveat'. (His capitals). Bliss had created in effect a dead language where the meaning is fixed although the translation can change with the living language of the translator. However, a dead language does not allow for evolution. To be effective a modern symbol system must be able to grow. While sympathising with innovators, iconography is only one of the many areas where the subject of copyright is being turned upside-down by computer usage and the information highway. Some of these issues will one day have to be decided by law. Others could be solved by common sense and a little generosity.

Symbols from the Olympic games. Aicher's grid designed for the 1972 games contained interchangeable elements that made up a 'body alphabet'.

Aicher's horizontal/vertical and diagonal grid for the Munich games.

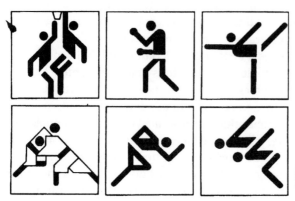

Examples of Aicher's interchangeable body alphabet. Reproduced from Honeywill (1994)

How ICI's logo has been altered over the years. Subtle changes are made to many well-known logos to conform to changing fashion and to influence consumers or clients without confusing them.

Designing icons

Icons, logos, symbols or whatever you care to call them, play a powerful part in all our lives today. Many people do not realise the influence they have over how we think and how we spend our money. Sponsorship Research International undertook a survey in nine countries using nine well-known logos. They reported (*Daily Mail*, 1995) that the five-ring icon of the Olympic games came out top with a 92% recognition rate. Joint second with 88% were 'McDonald s golden arches' and Shell and Mercedes following them with 74%. The Cross as symbolising Christianity trailed behind these symbols of capitalism at only 54% recognition.

To fulfil their function as efficiently as possible, icons need to be carefully designed. The poor quality of many computer generated symbols gives rise to considerable anxiety. The responsibility of designers within this area of modern iconic communication must be recognised. In other fields a craftsman or designer would expect to learn about the background of any individual or institution who commissioned a personal or corporate piece of work. In the design of an important logo or corporate image designers would consider it part of the job to research the whole spirit or aspiration of the company concerned and embody it somehow in their work. Yet some people, who will happily confess to having no conception of the issues involved in being a designer, undertake such projects. They seem to imagine that the computer itself has some magic that can not only work out how to express the ethos of a company but can somehow formulate a suitably clear graphic symbol to represent it – or encapsulate the essence of an object or action in an instantly recognisable icon.

Computers have not yet replaced the human brain in creativity or understanding, nor can they make qualitative judgements. To suggest that they can, without direction, convey meaning to a symbol is misleading. Too many people seem to imagine that, because they can handle a graphics programme they are able to perform complex design and typographic tasks by setting in a few instructions. A recent advertisement for a street directory trumpeted this message: 'It is as smart as a computer because it is designed by a

Logos can be designed to accentuate cultural ties. This symbol was designed by Paul Honeywill in 1993. It is based on the Mayan culture of the classic period and reflects the environment, in Belize, in which it it is expected to function.

The symbol source: Maya carvings at Xunantunich

Element of symbol superimposed over carving

Adaptation of Roman alphabet using established typographic criteria.

Reproduced from Intelligent Tutoring Media vol 1 1994

The design for the symbol for the International Book Year and some of the exploratory sketches, from Olyff (1973).

PRINT
BELIZE

NO 1 POWER LANE

B E L M O P A N

B E L I Z E C A

TEL 0 8 - 2 2 1 2 7

FAX 5 0 1 - 0 8 - 2 3 3 6 7

The finished symbol with type, on a letterhead

computer'. To undertake the challenging task of embodying a concept economically and clearly and aesthetically in a graphic image is a specialised skill. Some designers spend their whole career designing logos and allied tasks such as corporate image and it is an illusion to think that every graphic designer has this specific skill. Several experienced professional designers were asked for their views. One said, 'It requires a certainty of thinking; some graphic designers are better than others.' Another said, 'I am more of an illustrator, so discipline comes into place.' She suggested that the steps needed to refine and narrow down her ideas into the format for such a specific scale of design did not come at all naturally to her, even though economic expediency required her to undertake such jobs from time to time. Ray Hadlow, who specialises in logos went further in Sassoon (1985): 'Designing logotypes requires an ingenious twist of mind.' He advises anyone who designs logos to keep them strong and simple, explaining that, 'You never know how they will be used, any size from minute on a letterheading to enormous on an advertising hoarding'.

In addition to the designer's contribution, the appropriateness of the icon for its special purpose is of utmost importance, so cooperation with those in the specific field in which such icons are to be used is essential. No one should be so arrogant as to suggest that in some circumstances the practitioner's ideas might not be as good or better than the designer's!

One more thing. It is slowly being recognised that a screen is not always the same as a page. The use of letterforms, colour and spacing, or layout, in addition to the icons themselves, need even more care if the viewer is to achieve fast recognition without undue visual fatigue.

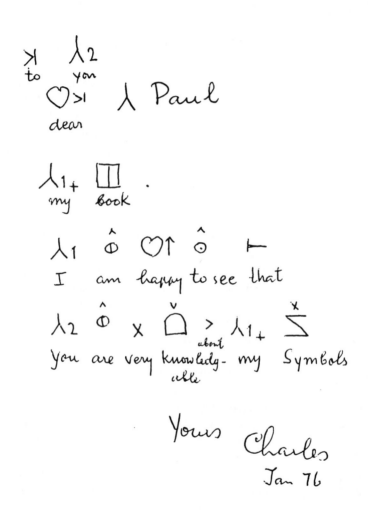

CHAPTER 5

Symbols and special needs

We nearly all make use of icons in our personal handwriting, often without realising it. These include the personal abbreviations of the word 'the' which have long lost the three separate letters, or for example, the many variations of an ampersand, but above all our signatures. The more people use their signature in their daily life or work the more abbreviated it tends to become – it is simply a matter of saving time. That abbreviation is suitable for a signature because it does not have to be legible, only consistent.

Extending the idea of iconic communication for those with special needs may only require ingenuity and no expensive equipment at all. Long before computers there were simple iconic ways of communicating with those who had lost the power of speech. A stroke patient did not need to be deprived of choice – in food, drink or many other ways. All that was needed was a home-made indicator board, which could be a simple piece of card with clear divisions ruled on it. Imaginative (but not necessarily artistic) rendering of whatever might be relevant in a specific circumstance was then needed – easy to recognise drawings of cups, glasses and items of food, etc. This simple technique restores not only a certain amount of choice for the patient (by means of the carer pointing, and some response from the patient in assent – a wink, a nod, whatever is feasable) but a modicum of dignity as well.

Computers have meant a great improvement in communication skills for those with special needs, and the use of symbols have a key function. In the article, 'The Contribution of IT to working with Symbols', Detheridge (1993) explains, 'Computer technology can provide the tools that will enable students to write using symbols. It will enable them to overcome any motor difficulties, and to be creative. The technology is also designed to support

This inscription appears in Charles Bliss's own hand, in a book belonging to Paul Green Armytage.

progressive development, it allows transition from symbol writing to using words and acquiring associated skills'.

Computers have restored the gift of communication to many severely disabled people, old and young. Voice synthesisers and voice recognition techniques are rapidly being developed, extending the more usual route to knowledge from the visual to an aural one.

A whole range of possibilities are available at the seriously disabled level or for those with less severe problems. Those with educational problems affecting their literacy skills can be helped by specially designed iconographies, which can also benefit those in mainstream education. So can computer generated oral learning, though that is not being dealt with in detail in this book.

These reading materials provide extra support for pupils with limited literacy. As each word is typed into the computer its corresponding symbol appears above the text. Illustration from Symbols in Practice (1993) *National Council for Educational Technology*

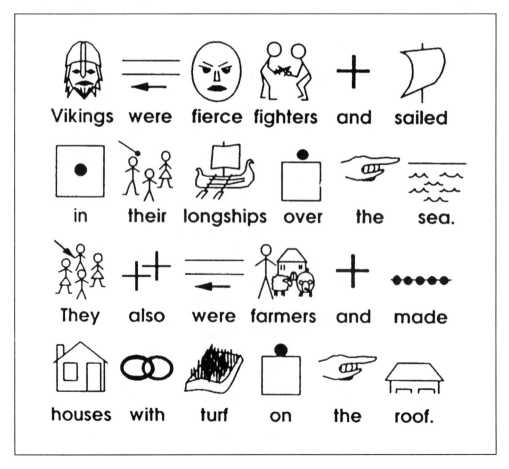

The taking in of information is one facet of education and the outputting is another. My own belief is that those who are physically able to write should not be put exclusively on a computer in any way that destroys their confidence in their own handwriting. Moreover, as Jill Day, who has written the section on Writing with Symbols, reminds us, keying in is a motor skill in its own right, and requires time and energy to perfect. One way forward even in our daily life, could be for us to use a mix of written icons combined with words to help speed up note-taking (many students do this already). The computer equivalent would be a stack of personal icons for key-saving – with a glossary if someone other than the writer needs to read the material. We must explore all possibilities for personal and international communication that the new technology is opening up.

Symbol Systems for Special Needs

Today a multiplicity of iconographies have sprung up around the world, many concerned with communication for the handicapped. In the field of what he termed Semantography, Charles Bliss tried to extend the idea of an iconography with his Blissymbolics. In Bliss (1966) the system is described as: 'A simple system of 100 logical pictorial symbols which can be operated and read like 1+2=3 in all languages. It can be typed and printed, and used in international communication and commerce, industry and science. It contains also a simple semantics, logic and ethics, which even children can use in their problems.' Bliss himself is said to have been influenced by the philosopher G W Leibnitz (1646–1716), who prophesied that one day someone would develop a whole language written in pictorial symbols.

Paul Green Armytage (who supplied the illustration on p78) attended a course of Blissymbolics with Bliss himself and attested how easy it was to learn. He added that indeed it clarified his thinking. In Bliss (1966) there appears a eulogy captioned. This is the vision of the friends of Bliss who realise that no man has done this before, providing such descriptors of the system as:

A writing which can be read in all languages

A writing which can give literacy to all

A writing which can expose illogic and lies
A writing which can unite our world, so disastrously
divided by languages, legends and lies.

Whether Blissymbolics, or any other iconography, can
achieve quite as much as his admirers suggest, many uses
have been found for his system, especially for helping those
with severe handicaps. His work is likely to have influenced
others working in similar fields in the intervening years.

Much that follows is concerned not only with the breadth
and flexibility of new specialised iconographies, but with the
economies and advantages that computers can bring to
iconic communication systems that preceded their invention
– Braille is only one example. An iconography in the process
of being developed for deaf signers for children, with, and
almost by, children is an inspiration to us all. However the
emotions that such innovations arouse cannot be ignored.
Very different viewpoints are expressed by different
generations. After all, it is not long since deaf signing itself
was frowned on, and only the training of lip reading was
permitted in schools. Many of the factors that need to be
balanced are discussed in this part of the book.

We must, however, be aware of some of the limitations,
even dangers, of being too dependent on or too complacent
about the ever increasing use of computers as a tool for
communication. Computers work within a framework that
controls what they can accept and what they cannot.
Programmes designed to help with communication
difficulties can either empower or limit the vulnerable user
depending on the range or flexibility of the vocabulary
employed.

As explained at greater length in Sassoon (1995), there is
a danger in imposing on people's thinking, other than when
it is essential, a computer compatible framework. In some
circumstances memory is replaced by an outside database.
The choice of extracts may still be intellectual and original,
but the basic matter is not original, so the mind may be
bent or limited by the material available to it. There is also a
worry that many decisions today are commercially rather
than intellectually led.

Writing with words and symbols

For all of us, symbols provide shortcuts to meaning. When we drive along a motorway, the picture of a jockey on a horse points the way to the local racecourse, an aeroplane guides us to the nearest airport. The road signs that we meet along the way give us information about the restrictions in force on the road or warn us of hazards ahead. We click on a symbol or icon on the computer to execute a command. We select a washing cycle at the touch of a button. Most of the time we absorb symbols subconsciously. Only when we encounter a new piece of technology or take a driving test do we consider the link between the symbol and what it stands for.

Symbols have long been used in the world of special needs as shortcuts to meaning. In the early 1970s research had established the value of using sign language with deaf mentally handicapped adults. Signs that represented the actions and meanings of words were found to encourage language acquisition among people hitherto considered withdrawn and uncommunicative. By the mid 1980s, systems had been extended to include a graphic vocabulary of symbols: pictorial representations of words and concepts that could reinforce the signing vocabulary in use. One of the advantages of symbols over signing was the concrete nature of the written form, allowing users extra time to comprehend the message and respond.

Bliss, Makaton, Rebus and Sigsymbols are all examples of systems that aim to supplement our traditional ways of communicating through speech and writing. At their simplest, these symbol systems consist of a library of pictorial representations providing information directly to the viewer. However, whereas concrete objects can be represented directly, relational symbols such as 'under', 'yesterday', and 'this', require a degree of abstraction. The grammatical structures that are needed to communicate complex sentences call for a graphic parallel to syntax and word order. Some systems, such as Bliss, have developed a more abstract style in order to provide a more comprehensive lexicon for users.

In education, symbol systems are used with three main categories of learners who find difficulty in communicating in speech and writing. The first category consists of a group of youngsters who are unable to communicate through speech. For them, a communication aid provides an alternative voice. By selecting words or symbols on a touch sensitive panel, they can direct the aid to 'speak out' their chosen message. Alternatively, by using a computer with a speech synthesiser attached, they can create and send messages to their listeners. Their needs as symbol users are very specific and therefore I am not focusing on them in this article.

The second category includes learners with severe learning difficulties who use symbols to interpret the printed message. The majority of these users will have a limited grasp of words and meanings, so symbols become an essential factor in their development of literacy. The third category are learners who have difficulty interpreting words

An overlay keyboard. By pressing the area on the overlay the text and symbols are transferrred to 'Writing with Symbols' ready to be printed out. (See page 86)

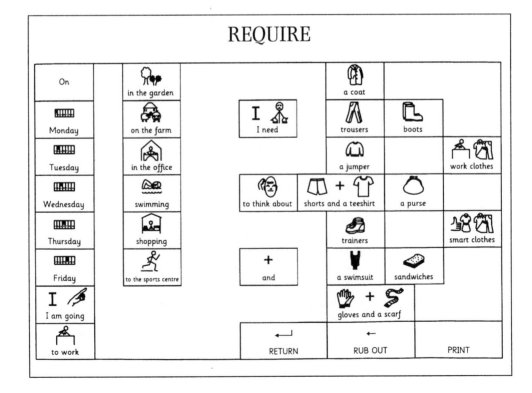

on the page. They may be second language learners or pupils with dyslexia who use symbols as an additional means of cracking the code of the printed word. Although there are differences between these two groups, for instance in their degree of dependence on symbols, there is much in common and therefore the case studies in this article are drawn from the last two categories.

Wall displays in schools can use symbols to reinforce messages and information. Symbols, hand drawn by adults for their pupils or photocopied and cut out, are used to annotate books, to allow learners to bypass the need to decode the text. Symbol charts and books can be used as communication devices by non speaking youngsters. In all these examples, the adult is in control, providing material for pupils to use. What was difficult, until the advent of powerful computer systems in schools, was for youngsters to select with ease the symbols themselves to record their experiences or attitudes, thereby gaining the independence to voice their own views.

Developments in Information Technology have overcome the difficulty for pupils who cannot use a computer keyboard to type words letter by letter. The overlay keyboard is a rectangular touch sensitive device attached to the computer that can be programmed to send messages to the screen. This keyboard is covered with a paper overlay, representing a selection of the symbols, pictures, words and phrases required. The student presses the overlay to 'write ' a message which is then displayed on the computer screen. Used in conjunction with a word processor which will present both text and symbols on screen, (for example 'From Pictures to Words' or 'Writing with Symbols') the youngsters can record their experiences in both formats. A speech synthesiser can speak back the text and the results can be printed out as a reminder of the activity.

Students at Ashwood, the extended education unit of Woodlands School in Surrey, use the computer with prepared overlays to produce their own writing. The students are between 16 and 19 years and have severe learning difficulties. Each week they are involved in activities in the community, within a curriculum designed to give them opportunities to make decisions, to take greater

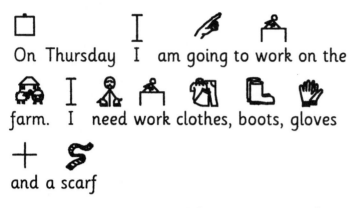

On Thursday I am going to work on the farm. I need work clothes, boots, gloves and a scarf

Students at Ashwood use an overlay keyboard to select the words and phrases they wish to include in their text. This list would then be ready to be printed out and taken home.

responsibility for themselves and their environment and to learn the skills to become more independent adults. Their teacher Gill Lloyd writes as follows:

'Students sometimes need to write notes to remind themselves what they should bring with them the next day. Previously a note might have been sent home asking parents to send in the equipment. Now, using the computer and overlay keyboard, the students can prepare their own aide-memoire, taking responsibility for their actions and providing a prompt for conversation at home about the day's activities at school.'

On Thursday, the group work on a farm and need to remember to bring suitable clothes. Sally uses the overlay keyboard to remind herself of what she needs to bring. As the whole group is involved in the activity, she offers to produce a copy for everyone, which she does herself, operating the computer and printer to produce enough copies for all.

An important skill for these students to learn is decision-making. By using overlays to build up a record of their work, they are encouraged to evaluate their achievements, much as their mainstream peers do. After work experience on the farm, Karen wrote about what she had done. She spoke about the activity with a member of staff, who asked her whether she liked the work and if she found it easy or difficult. Karen printed out two copies of her report, one for her Record of Achievement portfolio and one to take home to help her tell her family and friend what she has been doing.

Karen created this report of her work on the farm as part of her Record of Achievement portfolio. It provided a stimulus for discussion in her college interview.

The following term this same piece of writing, along with the photographs taken on work experience, provided Karen with a focus for discussion during interviews with the careers officer. She later took her portfolio to her college interview and described her time on the farm as an activity she had enjoyed. Karen is now at college and her friends still at the unit have dictated a letter to her.

For the students at Ashwood, symbols provide shortcuts to meaning. Where text is present on the page, it is there for the benefit of the helpers. Few of the students will become readers and so a symbol system becomes an alternative system of communication in its own right. However, for another group of learners, print annotated by symbols can

Hello Karen,

Are you working hard at Lufton.

We went swimming at the Water

Palace this morning. Do you go

swimming.

We have some questions to ask

you.

Do you go shopping?

The letter has been word processed, using 'From Pictures to Words' and printed out with symbols to support the text. Not only do the symbols help Karen to read the letter but they act as reassurance for the writers that the letter includes their points.

have a different function. Children in the early stages of learning to read, youngsters learning English as a foreign or second language, pupils with dyslexia, all can use symbols as a bridge between the spoken word and the abstract nature of the printed text. Here symbols are seen as a temporary prop, prompting the reader to use other cues, such as knowledge of sound/letter correspondence and context in order to identify words outside his sight vocabulary. The choice of words to be annotated in this way will be individual, dependent on the needs of the learner, and so the function of the symbols can be seen as an

addition rather than an alternative communication system in its own right, as it is for the students at Ashwood.

James and Greg have places in a literacy support unit at a local Junior School. As part of topic work on the Greek myths, they were writing a description of Medusa. Using a piece of software called Windows Concept, the boys with a member of the support staff, were able to program the overlay keyboard themselves with the pictures, words and phrases that they wanted to use. This in itself provided a valuable learning activity, encouraging them to brainstorm the subject and select relevant vocabulary for their description. Next, James and Greg used their overlay to input their words and phrases, interspersed with text keyed in from the computer keyboard. By using a symbol/word processing package, the screen will display the linked symbol above each word as they write. In this way the boys can be supported in their efforts to decode the text, both on screen and later when the printed copy is put up on display. Again, the use of a speech synthesiser or a sound card in the computer will give the added support of speech.

Pupils created their own overlay as a starting point for a description of Medusa. They used the overlay to write their text into 'Writing with Symbols' where the key words appeared with the relevant symbols.

commands.

She Had Gold wings

green scaly skin

Yellow teeth

green skin

gruesome

red Poisonous eyes

Slimy

deadly

Scarey

Enter

She Had Bronze Hands

Terrifying

hissing

↑ ↓

Print

turns People to Stone

gruesome red eyes

Space Bar

← →

Rubber

Recent developments in software are resulting in the emergence of more 'user-friendly ' symbol/word processors. Hitherto, the designing and editing of symbols has been a rather cumbersome affair, as was the selection of a library of symbols for use, but the software that is emerging will make it easy for users to select and even personalise symbols for their own needs. In some contexts, ready made libraries of symbols will be supplemented with the user's own creations. The addition of a speech synthesiser or sound card in the computer allows the symbols and text to be accompanied by speech. It is a similar tale with software for programming overlay keyboards. The availability of more powerful computer systems in schools and colleges allows for more flexibility in software designs. The result is that, as James and Greg found, the capability to program the overlay keyboard can be within the users' grasp.

What effect will the presence of these more powerful computer systems have on the traditional ways of working with learners? I have already indicated in my examples the ways in which the new technology is affecting the learning process, encouraging learners to take decision-making into their own hands. In addition, the ability to link words and pictures with ease is encouraging teachers to consider ways of working with a wider range of pupils, harnessing the power of the technology to support individual learning needs.

It is important that we as teachers are clear about the function of symbols when we are using the new technology with our learners. For Karen and Sally, symbols provide a permanent means of communicating with their peers as well as giving and receiving information. For this reason, it is important that the graphic images used are consistent, part of a recognised system, so that they can be understood by all in the community. The symbol glossary must be appropriate to the needs of the users. By limiting the symbol vocabulary available or the syntax of use, we are in effect limiting the opportunities for our users to communicate. On the other hand, for James and Greg, symbols are a more transient affair. Here the emphasis is on the printed word and the existence of symbols merely serve to annotate the text for the learner. For this reason, the choice of images

can be more personal and the range of symbols available can be expanded to meet the demands of a new topic.

The ease with which new symbols can be created and imported into new libraries has implications for the existing systems in use. Up to now, the choice of new symbols has lain in the hands of a small body of authors. Uniformity of design and graphic standards have been maintained in this way. Now, in the same way that words are the property of everyone, pictorial representations will be in the public domain and any user will have the power to create a symbol that he thinks is needed. Symbols from different systems will be mixed in libraries and the criteria for adoption will be their appropriateness to the current situation.

Whereas this relaxation of the rules of symbol generation may not be significant to the wider group of symbol users, it is important that we do not forget the needs of the community that is dependent long-term on symbols for communication. For that reason the foundation of the Symbol Users Advisory Group to promote the use of symbols in the United Kingdom is a significant step: its aims are to promote the use of symbols and provide information on the different types of symbol systems in use in the country.

Technology, as ever, has given us the power to perform mechanical tasks more easily, leaving us to concentrate on the 'higher order' operations. We do not have to think about the mechanics of drawing symbols but can focus on the ways we choose to use them with our students. But if we do not take with that freedom, the responsibility to consider the effects of our choices, then we will be doing a disservice to our learners and in particular to the needs of the community most dependent on the technology for communication.

the quick brown

fox jumps over the

lazy dog

Braille typefaces designed for Iceland by Gunnlaugur SE Briem. The typeface with a grid of small dots makes it easier for sighted people to type, proofread and arrange text before it is embossed.

CHAPTER 6

Symbol systems for the visually impaired

The first is standard Braille.

The second has small dots where dots are normally left out.

abcdef

The third has the same letter, in Braille and the Latin alphabet, on each character. Strike a key and both appear. The Icelanders, who use no abbreviations, say this is very useful.

The history of iconic communication for the blind is an interesting study in itself. It mirrors many of the points relevant to other symbol systems described in this book – how and when it was decided to concentrate on one particular system, how to bring a system that has served its users well in the past into the computer age, and how to adapt and simplify without sacrificing quality and without destroying the confidence of the older generation in a skill that they have so laboriously acquired,

Most people have heard of braille, devised by the Frenchman Louis Braille in 1829. His system had its origins in an embossed code of dots invented by Barbier, an artillery officer. It was intended to be used to relay battlefield messages in the dark when it would be unwise to reveal a military position by using a lantern. Here is an example of an iconography evolved for one specific purpose finding its ultimate destiny in quite a different field.

Braille alphabets (there are slight national variations) basically consist of varying combinations of one or more raised dots in a six dot oblong known as braille cell. A cell is three dots high and two dots wide. There are sixty-three possible combinations which provide for all letters of the alphabet and punctuation, plus a blank cell for word spacing.

Moon
There is another system in use which can also be termed iconic. It is intended for blind or partially sighted people of any age who find braille too difficult to feel or learn, and is particularly suited to the needs of the deaf/blind. This is Moon, a method of reading and writing by touch using raised shapes invented by Dr William Moon in 1845. It uses lines and curves to create nine basic shapes, which when turned in different directions create the letters of the alphabet. As a result many of the simplified letters resemble some features of ordinary capitals, and the letters C I J L O V

⌴ꓲO꜔\ꓥ⌵O⌄O⌐ Oꓩ ∩ꓲꓶꓵꓥ꓄ ꓄OOꓠ

and Z retain their exact forms.There are abbreviations for the words 'and' and 'the' in the standard alphabet and many other contractions for space and time saving in more advanced (grade 2) Moon, according to information supplied by the RNIB (Royal National Institute for the Blind).

There is more to say about Moon in relation to computer generation of symbol systems. Dr Gill, technical advisor to the RNIB, considers that the present day attitude to Moon is production driven rather than devised with consideration for the physiology or skills of the users. Moon includes reversals of several characters making design and production simple and inexpensive. He explained that Moon was originally set boustrophedon, i.e. one line reading from left to right and the next right to left – bracketing together two lines at a time for speed and practicality. This layout allowed for the closer spacing of lines of text than is desirable for recognition by touch. When boustrophedon was used at various times in the history of the development of writing for the sighted, it was efficient to write. When reading or writing from right to left the characters themselves are reversed. Today, at first sight, a passage set in this way looks unfamiliar. However, the eye soon accustoms itself and allows the reader to decipher the message.

Moon is now produced by computer, that is to say the embossing of books can be undertaken by computer rather than being hand set. Dr Gill himself has developed the programme that would allow users of Moon to have the same facilities that apply to braille users – i.e. easy access to computer software that enable users to input into the computer in Moon, with a voice simulator to help with accuracy, and a capability to output any text either in print or Moon (or presumably braille). However, it is not yet generally available. Dr Gill's main concern is for deaf-blind

Biography of William Moon (written in Moon) from Stroud (1992).

An example of embossed Moon, same size. This illustrates how two lines used to be linked together showing the original boustrophedon layout.

users for whom such a programme (though not of course the voice simulator) would be invaluable as they are today perhaps the most frequent users of Moon and most dependent on it for communication.

In the changeover to the computer production of the embossed Moon characters, the boustrophedon layout has been altered. Now Moon is presented as reading only from left to right. It would be interesting to know if this change in layout has affected the ease of reading. Whether it is now easier for the readers or easier for new learners, remains to be seen – but it probably helps the producer.

Other codes

In the 19th century there were various other codes in use including Gall and his system of angular forms of capital letters. Gall realised that the more angular the letters became, the easier they were to recognise by touch: but the further he went in that direction, the less recognisable his alphabet became for sighted teachers. Lucas was working at the same time on an abbreviated code. As Lorimer (1994) explains: 'Instead of letters, his symbols were a combination of straight lines, curves and dots. He used single and double letters to represent words, often with at least two meanings to a sign. Although this idea of tactile stenography saved space, interpretation often became guess-work, depending too much on context'.

This proliferation of iconic systems was recognised as undesirable and in 1868 a committee was formed under Dr Armitage to study the various codes in use. Two years later the decision was made in favour of braille, which apart from its ease of reading, was the only embossed code in general use in Britain at that time.

A review of research on 'The perception and cognition of braille characters by touch' in Lorimer (1994) gives the general reader some idea of the complexity of problems still to be resolved. These include the physical characteristics such as the spacing variables of dots, i.e. the distance between dots in cells, the spacing of cells and between lines. These resemble the discussions in typography concerning optimum size, word spacing and line spacing for easy reading at various stages of life. Lorimer discusses how: 'Some teachers advocate the use of jumbo dots for early learning, while others think the standard size fit more conveniently under the finger pads thus aiding quick recognition, whereas the larger size encourages scrubbing. This refers to the movement of fingers up and down in a rotary movement in order to determine the shape instead of developing a light sideways movement across the characters.' In a section on reading techniques Lorimer makes this interesting statement: 'Teachers of braille reading tend to be so involved in monitoring a child's reading for accuracy, comprehension and speed that they often pay insufficient attention to how children use their

A page from a 1979 Chinese Braille manual.

中国汉语盲文符号

一、字　母

声母：　b　p　m　f　d

t　n　l　g,j　k,q　h.x

zh　ch　sh　r　z　c　s

韵母：　a　o,e　yi,i　wu,u

yu,ü　er　ai　ao　ei　ou

ya,ia　yao,iao　ye,ie　you,iu　wa,ua

wai,uai　wei,ui　wo,uo　yue,ue

an　ang　en　eng　yan,ian　yang,iang

yin,in　ying,ing　wan,uan　wang,uang

wen,un　weng,ong　yuan,üan　yun,ün

yong,iong

hands. A close study reveals a great deal of variety in the use of hands and fingers, and it is necessary to know as far as possible what is the best method for each particular child.' She goes on to say that it used to be thought that two-handed reading, the first part of the line being read by the left hand and the second part by the right while the left hand found the next line, was best. It seems the most economical of time, but depends on which fingers are most sensitive.

This attention to individual needs seems vital, and mirrors my attitudes to the attention that should be paid to writer's hands and the motoric attitude to training needed to help children to develop efficient handwriting strategies. It seems to me that those involved in the computer generation of braille should heed these comments, and provide facilities for personal adaptations of size and spacing in particular.

There is a further consideration. That is to consider the needs of sighted people when learning braille. This was raised by my colleague Briem. He is involved in a project for developing new computer-generated braille characters for his native Iceland. The illustration on page 92 shows how retaining a faint grid within the cells might make recognition easier for sighted learners or users of braille.

Braille crosses language barriers and in some circumstances the barrier of writing systems. The illustration on page 97 shows how recognisable braille configurations (in 1979) denote the basic phonetic values in Chinese words. The four different tones of the Chinese language can be indicated by positioning additional strokes above the traditional braille cells.

Another step forward in the history of communication for the visually impaired has been necessitated by the computerisation of braille and technological advances in international communication systems. While broadening horizons for braille scholars and raising their expectations accordingly, certain problems concerning international standardisation have arisen. The present situation is reported here by Isobel Yule.

The unified braille code project

Isobel Yule MDDA Dip. Ed.,Dip CIB., who wrote this section, is vice-chairman of the Braille Authority of the United Kingdom, Treasurer of the International Council of English Braille, Member of the Braille Literacy Committee of Teachers Association (VIEW), Chairman of the Braille Promotion Committee, International Member the Board of Research Centre, American Printing House, Louisville, Kentucky, Braille Tutor for Distance Learning Course Birmingham University and Head of Braille and Braille Technology, Dorton House School, Sevenoaks.

Despite the uniformity of the braille font, the diversity of codes have emerged through the years in different countries and the symbols represent different meanings in disciplines such as mathematics, science, phonetics, computer codes, foreign languages and music. Even in the English speaking countries there are marked differences in the mathematics codes. A student studying mathematics and science in the United Kingdom would have to learn a completely new set of symbols to be able to undertake a course of study in the United States.

A completely unified braille code would eliminate such differences and such an idea originated in North America in 1991. The Braille Authority of North America, the braille standard-setting body, introduced an initiative to carry out a research project to determine if the literary braille code could be extended to allow the codes used for the technical to be embedded into it.

As a result of a meeting of the International Council of English braille in Sydney, Australia, in June 1993, other English speaking countries now have full participating rights. The national standard-setting bodies will be free to decide whether or not to ratify final proposals that emerge after evaluation and field testing. The work has already begun and future discussions on the research project will be at international level.

Some guidelines and objectives
Readability
The preservation and, it is to be hoped, the improvement of the readability of braille is the most important objective. Because it is, readability must not be impaired in order to realise any other objective. In addition, the unified braille code must be readable to both beginners in braille reading and to advanced braille readers. In the interest of readability the base code must be as much like the current literary code as possible, so that the demands placed on braille readers for learning the new code will be minimal.

Scope

The UBC must make provisions for all of the symbols used in Grade 1 and Grade 2 braille, and all of the symbols that may be needed in maths and other scientific and technical disciplines. The music notation was felt to be a special case requiring special treatment.

Contractions

Although a few contractions may be dropped from the base code, no contractions should be changed, and no contractions should be added. Strict adherence to this guideline will minimize the new learning required for those who now read braille.

Uniqueness

Each symbol must specify one and only one symbol in the print code. Adherence to this guideline will require a few changes in the current braille code to bring about parallel forms of representation in braille and print.

The adaptive technology that is now widely available has made it possible for blind persons to interact with sighted ones in the performance of tasks that depend on print for the production and exchange of information. For the interaction to be efficient, blind persons must understand the way meanings are represented in the print used by their sighted colleagues: therefore the maintenance of parallel forms of representation is essential.

Translation by computer

Computer translation from print to braille and from braille to print should be as free from error as possible without sacrificing readability. Adherence to this guideline reduces the human labour required for the production of braille, and in so doing, increases the quantity and reduces the cost of braille text.

Extendibility

A set of rules must be developed which, when rigorously applied, ensure that extension of the base code to encompass symbologies in various scientific and technical disciplines cannot result in ambiguous symbols.

Symbol boundaries

Because only 64 combinations can be formed in the braille cell it is not possible to provide a unique combination of dots to represent each print symbol. The only solution is to use one or more braille characters for some print symbols. Therefore braille symbols must be constructed in such a way that the reader can always determine the boundaries of braille symbols regardless of the number of characters needed to form them.

Finally, the need for rule simplification in the interest of making braille easier to learn by both young and old, and the common base code embracing the technical disciplines must be the main objective for all code designers.

Isobel Yule also discussed the present state of technology starting with the inputting of braille by means of a braille keyboard which can also have speech output or a braille display. The braille can then be converted to inkprint.

'Other technological advances in print accessibility are the optical character recognition such as the Kurtz Weil personal reader, the Arkinstone Open Book, or text readers linked to personal computers. This major breakthrough has enabled a visually impaired person to scan a print document and then read it directly on the computer or via adaptations such as a braille display or synthetic speech. Data base systems with the aforementioned adaptations allow easy access to bank transactions and telephone directories. The most recent development in this easy storage system is the CD Rom. On average they allow about 400 megabytes on a disc which is ideal for storing encyclopaedias and dictionaries again accessed by synthetic speech or braille displays.

Some researchers working in the field of computers already feel that the use of 8 dot braille, exacting a total of 255 combinations, would be a better system for the computer code used on a braille display unit. Also in the transcription of music, the 8 dot cell would be more concise.

Perhaps the most exciting aid to more efficient communication between visually impaired persons is the exchange of information on disc nationally and internat-

ionally. But a note of warning is that braille standards should never be sacrificed at the expense of advancement of new technology, nor should technological development be quashed therefore denying the blind the advantages that hi-tech equipment is affording the sighted world.'

Balancing issues

It seems to me that Yule has admirably balanced the issues involved at the present time between promoting worldwide communication at the highest level for the partially sighted and understanding the compromises that nations must make in order to facilitate this communication. Her warning about the dilution of excellence in braille standards should be heeded in other disciplines where such standards are not always so safely guarded in the rush for technological advance. It was only as I read more deeply into the history of codes for the visually, hearing or learning impaired that the same pattern of principles as well as problems and the same balancing factors seemed to recur in relation to computerisation.

Isobel Yule, who has been blind since childhood, told me that, in addition to modern technology, a personal reader is another necessity for the professional. She explained that only 10% of visually impaired people can read fluently in braille and that when you listen you absorb knowledge in a different way. Appropriate listening and study skills need to be taught, particularly when a person cannot learn the orthography. Yule also mentioned that sometimes there is a psychological barrier between listener and reader and that the reader's interpretation may intercede. She stressed, moreover, that if you read directly to yourself you control the input.

In addition to the list of technological aids provided by Yule there is another rapidly expanding facility to be considered – that of computers which allow the user to control them by their voice. In *Sounding Out* (1994) an NCET booklet, their usage is described in this way: ' This effectively means using a microphone rather than using a mouse to make the software work. Once the computer has been trained to recognise a voice, the user can speak into the microphone and the computer will perform the required

action.' This is departing somewhat from the subject of iconography but the diversity of new technological forms of communication cannot be ignored and must be combined and used as appropriate, particularly for those with special needs. This is set down with the understanding that almost anything written about computer technology is likely to be out of date before it is published.

Points of discussion

In talking to a variety of people involved in education of the visually impaired, the same arguments arose time after time. In some ways these matters are mirrored in other fields where complex communication techniques were in place for many years before computers came into use.

Economic considerations: as many cannot afford computers, what will happen to them after school, in particular the less talented? At the other end of the scale, the more competent the visually impaired individual may be, the more he or she will require all modes – scanner braille/type, brailler and talking computer. The spread of computers which has so benefitted and enlarged the horizons of many braille users has itself led to problems as they expect and deserve to profit from the worldwide communications network.

Some of the older generation seem suspicious of learning from a speaking computer. They cite the problems of learning aurally. Perhaps they feel that the skill of brailling that they have perfected over so many years will somehow be devalued or that they will find difficulty themselves in mastering new technology. Listening skills, however, can be taught and can be developed relatively easily. The present generation, which is being brought up using this mode of learning and which is more at home with new technology, will most likely have different views.

Braille is difficult and only a proportion, say 10%, can read it fluently. Will someone decide one day that braille is too expensive and lengthy to teach and suggest only the use of talking computers in the future? Perhaps this is the fear in the minds of those who see modern technology as a threat.

next day

sad

smiling

"Come with me"

must

fire wood

as they went along

dropped the pebble

onto the ground

Next day Hansel and Gretel saw that their father was sad but their step-mother was smiling. Their father said, "Come with me children we must go into the forest for firewood." So their father took Hansel and Gretel.

Now, as they went along Hansel dropped the pebbles onto the ground.

An example from a reading book with a glossary of unfamiliar words in Sign Graphics.

CHAPTER 7

A new iconography for deaf signers

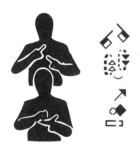

The newsletter, The Sign Writer, *written in Signed Languages & Spoken Languages. The Deaf Action Committee for Sign Writing, La Jolla, California.*

Below left: Sign Graphics set can create drawings to depict signs. Right: Fingerspell font helps learners to develop skills in fingerspelling and link them to literacy. Reproduced from SEMERC catalogue (Jan 1996).

It was at a conference on computers and writing that Rob Baker, then of the University of Leeds, talked about an interesting new project. He pointed out that to the deaf, English is a second language and the Latin alphabet a second writing system. The description that he gave of the iconography based on hand signals, being worked out by the group of deaf children under Sarah Head in Derby, was even more fascinating.

There is already a computer generated iconography in the US. This works with American sign language but what is reported here is the evolution of a new iconography, designed in the UK with children and for children, specifically for use on the computer. In itself this is a highly imaginative project but as an example of a new iconography it has lessons in principle. The innovator is herself deaf and talented artistically so she is able to create appropriate symbols and to inspire others to follow her. The concept is extendable and from the outset designed to make best use of computer technology. For those of us who are not familiar with the use of Sign Language, Sara Head gives a lucid explanation of its rationale and usage.

Sign Graphics: My World 2

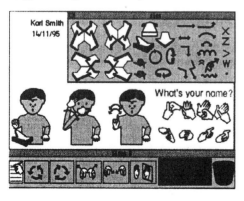

Sign Graphics: Fingerspell Font

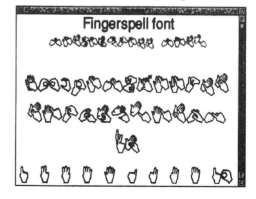

The use of sign language graphics in bilingual education for deaf children

In the primary department at the Royal School for the Deaf, Derby, BSL (British Sign Language) is the main language for communication, teaching and discussion. English is considered the children's second language and has two forms: written/read (literacy) and spoken (oral). This section focuses primarily on literacy.

As to the staff of the school, some of our teachers and assistants are themselves deaf and some are hearing. The reason that we use BSL is that it is a visual language, perhaps closer to the way deaf children think than any other language. It is easier for deaf children to learn through contact and communication with deaf adults. Deaf children do not need to be 'taught' BSL in an artificial way; they acquire it easily and quickly through interaction. Developing fluency in BSL gives the children an internal language for thinking. We do not teach BSL as a subject but teach all subjects through BSL.

Using BSL allows the children to ask questions, answer questions, discuss, problem-solve, enjoy stories, tell stories, joke, argue – in fact BSL is used in much the same way that hearing children use English in hearing schools. A bilingual classroom environment increases not only the children's understanding, but their confidence as the children know that they will be able to understand everything that is said in the classroom and everything that they say will be understood. BSL is not a method but a language that can be used to give access to any teaching approach. As well as giving access to the curriculum, we consider BSL to be the children's first langauge which we can use as a base for helping them to learn a second language, English.

The teaching of English is in two parts, literacy (reading and writing) and oral English. Oral English is not taught in isolation but has its foundation in the children's developing competence in written English.

This section was written by Sara Head when she was a teacher at the Royal School for the Deaf in Derby. This account of her work first appeared in the summer 1992 issue of the journal Laserbeam.

The use of sign graphic glossaries and comprehension questions

When we teach deaf children to read we encourage reading for meaning. It is possible for children to be able to 'read' every word from a text by signing, fingerspelling or speaking, but not actually to understand what they are reading. We consider it vital that deaf children learn to read looking for meaning. One way we do this is to encourage 'silent reading'. This allows the children to use whatever strategies help them to understand the text. It also helps to stop them from seeing reading as an exercise where they 'perform' for the teacher and to start to see it as a task in looking for meaning in information.

An example of how we do this: I will write a letter to the children about my weekend which I will put up on the board together with a glossary of any words they might not have met before. I use drawn signs to explain the words. (See page 104 for an example from a reading book with a glossary of this kind.) The children read it silently to themselves. They can ask me if they come across a word they do not know and I will add it to the glossary as a drawn symbol. When they have all read the passage I ask questions about it in BSL to see how much they have understood. The complexity of the questions depends on the level of comprehension of the child I am asking. If the child cannot answer the question we go back to the passage and look at where we can find the answer. Asking questions in BSL helps us to check comprehension and allows us to explain grammatical features of English as and when appropriate. Page 108 shows a simple written comprehension sheet with questions in BSL graphics.

How and why these sign graphics were developed

The sign graphics developed because we were looking for a way to make sure that the children actually read the text. We had noticed that sometimes it is possible for children to write the correct answer to comprehension questions without really understanding the whole passage. For example, they look for a key word in the question, find the same word in the text then copy out that line and answer. By using questions written in sign graphics we ensure that

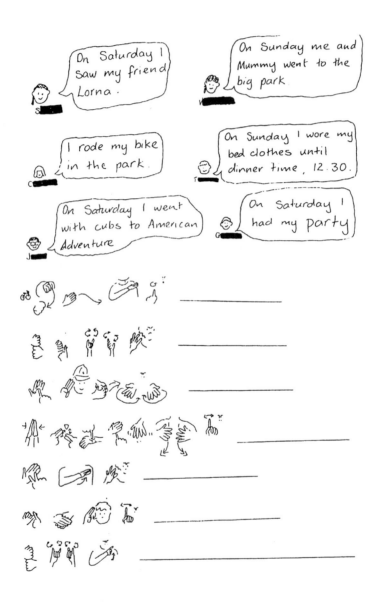

A simple written comprehension sheet with questions in BSL graphics.

to answer them the children must have read and understood the passage in English. Interestingly, the children never have any problem in understanding the question written in sign graphics.

The use of BSL/English phrase books
These started because children were coming to us and asking for spelling of signs which could only be spelt in English as a phrase. We find it very important that the children understand that English and BSL are different languages, therefore phrase for phrase translation is often needed, not word by word. Below, is an example of a page from a BSL/English phrase book (the sign 'fed up' was drawn by a 7 year old boy.

A page from a BSL/English phrase book (the sign 'fed up' was drawn by a 7 year old boy).

Creating writing in sign graphics

As an experiment, I asked the chidren to 'dictate' a story to me in BSL which I wrote down as they signed it in sign graphics. The reason behind this was, firstly, to help the children see that 'marks on paper' have meaning. Secondly, I wanted to help them with the skill of structuring their thoughts when putting information down on paper.

The first story we did like this was Icarus. One child was away when we wrote this story. When he came back I gave it to him without comment. He took it and sat and read it through silently to himself while his hands 'twitched' small signs. When he'd finished he stood up, gave it back to me and said 'Good story'. It struck me that for the first time this child had been able to sit and read a story through without needing help from anyone. He was reading for pleasure a story in his own language.

We continued to work together while I drew the signs for stories the children dictated. I found it provided a good opportunity to discuss sign use. The children started to argue about the 'best signs' for the story and were able to justify their choices. When we were writing the story of Rapunsel a 6-year-old girl and a 7-year-old boy argued over the sign for 'looked'. The boy said it should be the handshape for 'eyes' swept down in a curve from the eyes, whereas the girl said it should be the same handshape but moving straight outwards. The boy said it should be his because the man was scanning a row of lettuces under the wall, which everyone agreed was a good reason. Then the girl said, 'No, it should be mine because the man is looking at the cat in the distance.' Both children were able to justify their choice of sign and know why in different contexts they were grammatically correct!

Another use for sign graphics is to keep the signs on the page in order to contrast them with English. This helps the children see that the two languages have different structures for presenting the same information. This is called 'contrasting analysis'.

The more sign graphic stories we did, the more critical the children became of my drawings... the shoulders were not quite right or the facial expression wasn't quite right. In the end I said 'Well draw it yourself then'... so they did!

All the children started using sign graphics. An advantage was that it meant the children could write anything they wanted without needing any assistance and without having to know the spellings. Even the children who were not brilliant artists were able to draw sign graphics. This was the first attempt of a boy aged 7.

This was the first attempt of a boy aged 7 to draw sign graphics.

What was noticeable was that when the children read the signs back to me, they added appropriate expression, body movement etc. and read with fluency and meaning.

Sign graphics and English

One boy who only wrote English very slowly and without much confidence started doing everything in sign graphics. He was able to read back everything he said. On page 112 is a letter to me. It translates as: 'I went to M...T...'s house. We played trains. Now it was K's birthday. That finished then we went back to the house and played trains. Daddy came. I went.'

He drew signs quickly. However, after a week in which he had done all his work in sign graphics, I was beginning to wonder whether perhaps I had stopped him using English. The following week, however, he wrote a second letter to me in class without assistance. He had started to mix both sign graphics and English glosses.

He continued to use both sign graphics and English words for about a week when he dropped the sign graphics completely. It was interesting to note that after he had been using the sign graphics the content of his writing improved, although there was no improvement in his English grammar. I was keen that the children should not mix BSL and English but to keep the two languages separate.

The children only used sign graphics for a short time before returning to English use, largely I think because of the time element. It is quicker to write English than to draw signs. However the quality and content of all the children's

Overleaf: two letters written by the same boy just a week apart.

SW ★ SW ★ SW ★ SW ★ SW ★ SW ★ SW ★ SW ★ SW ★ SW ★ SW ★ SW ★ SW ★ SW ★ SW ★ SW ★ SW

PowtollPlace

Dear Miss Head

from Graham
aged 8

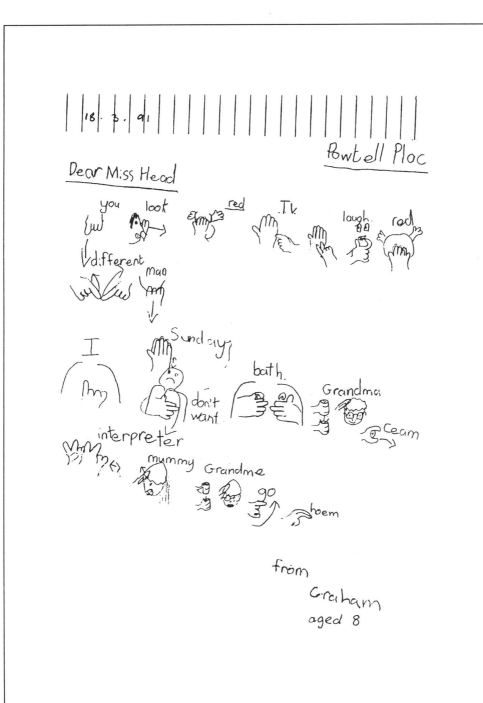

from

Graham

aged 8

writing seemed to take off after this period, with children producing pages of writing full of interest and imaginative ideas. Whether this had anything to do with the use of sign graphics I do not know, but I think the children benefitted from the experience, realising they could write anything they wanted to unassisted. It was interesting to see the clear stages of the children's development in writing sign graphics and it may have more use and implications with younger children.

This account allows us to look in detail at the early development of a unique iconography. It developed for a specific purpose led by the needs of the children involved and by the enthusiasm and talent of their teacher. Sarah Head presents cogent arguments for the use of BSL in education and details the benefit it brings to deaf children. In another part of her writing she showed how BSL sign graphics could be used with a concept keyboard with overlays produced for the computer to contain either words in most common usage or of the child's own choice for whatever specific purpose. Rob Baker and Steve Partridge now present a report of the progress that has been made in this project since the original article, which concerned work undertaken in 1992.

Sign Graphics – sociolinguistic issues

The work outlined in the section by Sara Head focuses specifically on the use of sign language graphics in the early literacy teaching of young deaf children. Since the original publication of Sara's work researchers in Leeds have developed a method for creating sign language graphics on the Archimedes computer. The system 'Signs', designed by Steve Partridge (Partridge, 1994a) to operate in conjunction with North West SEMERC's highly successful 'My World' software package, enables deaf pupils from a very young age to compose sign graphics on the screen, using menus of sign components, viz hand-shapes, body-shapes, facial expressions and movement symbols. The intended

Rob Baker is a lecturer and researcher at the University of Leeds, with a special interest in the education of the deaf. Steve Partridge is a teacher of the deaf in Leeds. He was involved in the development of the Sign Graphics software illustrated on p 105

applications are similar to those of Sara Head's hand-drawn graphics, i.e.:

· development of pre-literacy skills in the child's first or preferred language so that these skills can then be transferred to English

· opportunities for self-expression in the child's preferred language

· ability to create permanent records of sign language events

· opportunities to enhance the perceived language status of British Sign Language (BSL), especially through homework and classroom display, thus giving deaf children a sense of pride in their preferred language.

In addition the package has certain characteristic advantages over hand-drawn graphics:

· it enables well-formed sign graphics to be produced by pupils and teachers who may have limited freehand drawing skills

· it enhances metalinguistic awareness of the formational components of a visual/gestural language

· it fosters transferable IT skills, e.g. mouse manipulation, selection from menus

However the potential for more widespread use of sign graphics engendered by a computer based approach has also raised broader issues about (a) linguistic acceptability and (b) 'language planning' (Haugen, 1966).

The first of these issues arises directly from the potentially wider educational use of sign graphics, i.e. wider than just for students' personal writing. Vocabulary lists, worksheets, classroom displays and school notices (perhaps even some school documentation) can be produced fairly easily using the 'Signs' program, even by people who may not be fully

competent in BSL, e.g. young children or hearing teachers. This poses problems of quality control and has resulted in the establishment of a Sign Graphics Working Party in Leeds LEA. According to current guidelines (Partridge, 1994b), graphics produced for public display are required to be vetted by a qualified deaf adult. Definitions of what constitutes qualification are under discussion but a working criterion might be a qualification in teaching BSL such as that offered by the University of Durham. Whereas these moves are positive in terms of the vital need to establish BSL as a proper medium of discourse throughout the educational system, there will be some teachers who object to the whole notion of 'tidying up' children's work for display. Nevertheless, a higher profile for these issues is to be welcomed.

Involvement in these discussions has inevitably led to deaf adults taking a more critical stance towards the whole concept of sign graphics. Criticisms focus particularly on the potential use of sign graphics beyond the educational context. There are two fundamental issues here:

i) perceptions and expectations concerning the design features of writing systems

ii) attitudinal factors relating to language change and language planning

Most writing systems have evolved to achieve a compromise between the demands of reading efficiency and writing efficiency. Writing calls for a considerable amount of abstraction from the highly patterned acoustic signal in the case of spoken languages, and from visual images that are even more complex in the case of signed languages. Having lived with the alphabetic principle for at least 3000 years, the human species is now well accustomed to the order of abstraction required for writing down spoken languages. Thus for example, the orthographies of spoken languages generally convey very little intonational information and nothing of an individual's voice quality. Sara Head's samples of deaf children's own writing in sign graphics provide evidence of various abstracting principles in action. It is not

surprising that the selectivity of this process should cause controversy amongst native signers, e.g. under what circumstances is it essential to show facial expressions and spatial relationships between hands and body; when may it suffice to show hands alone ? The designer of a sign graphics system should as far as possible avoid pre-empting or constraining such issues, trusting to evolution to take care of them.

The demands of efficiency in reading sometimes conflict with the need for economy of symbols in writing, most notably through the notion of redundancy. We can trace the evolution of redundant features in the development of modern European alphabets from their Roman parent, particularly in the introduction of spaces between words and of the ascenders and descenders of modern lower-case lettering, which render written messages legible under varying noise conditions. The sentences below illustrate the point. Try laying a ruler over the bottom half of each line of text and observe the differences in legibility.

Roman lettering IAMINIIMINDSABOUTIT

Modern European lettering I am in 2 minds about it

It is evident that this kind of redundancy to support reading is a secondary development contingent on increasing use of the writing system. It is also likely to develop in a somewhat haphazard way, as in, for example, the maintenance in English of archaic orthographic forms of some derivational morphemes, e.g. nation /neish-/, native /neit-/, national /nash-/, thus no longer accurately reflecting pronunciation, but preserving semantic relationships intact. How such a process might take shape in sign graphics remains to be seen. In an era of multimedia IT there are likely to be many influential factors that could not have come into play in the early development of spoken language orthographies.

Sign graphic materials have now been demonstrated to deaf and hearing gatherings at several conferences and workshops. The idea of 'writing' sign language has met with reactions ranging from enthusiasm through incredulity to

downright hostility. Negative comments are generally framed in one or both of the following ways:

a) we don't need a written form for BSL; we use video for that

b) we don't need a written form for BSL; we use English to fulfil that function

Both these comments allude to obvious functional attributes of writing systems in general, viz. the desire to keep permanent records (a and b) and the inherent flexibility of paper as a recording medium (b only). However we may speculate that a complex of attitudinal factors underlie the statements. Before attempting to identify these factors it is worth mentioning that there have been other attempts in recent history to promote writing systems for sign language in Europe and North America, so far without much success. Some of these systems are reviewed in Papaspyrou (1990). What could be blocking acceptance ?

The story of Sequoyah, inventor of the Cherokee syllabary, is instructive (Walker, 1969). In the early ninetenth century Sequoyah observed the white settlers moving West across the continent and was struck by the power apparently wielded by their written word, especially in the form of the Bible. He set out to devise a writing system for his own people, eventually completed in 1819. Within 11 years there was 90% literacy amongst the Cherokee in their own language. Even more staggeringly, by 1880 levels of literacy in English were higher amongst the Cherokee than in the surrounding white population of Texas and Arkansas. However, Sequoyah took 12 years to develop his system and during that time he neglected his farm and family and was accused of witchcraft by his own people.

One's native language is closely associated with self-image and sense of identity. People are highly sensitive to any 'tampering'. Haugen (1966) has recorded the major political struggles that accompanied the development of two competing orthographies for modern Norwegian. There has been steadfast resistance to spelling reform in Britain and to

the Romanisation ('modernisation') of the writing systems of China and the Indian sub-continent. For deaf people such protectionism is likely to be reinforced by issues of language status. Sign language has been subject to an almost continuous history of oppression and suppression for over a century, particularly in the education system (Lane, 1984). The tyrannous influence of standard spoken languages and their written forms has led to considerable suspicion about devising parallel systems for writing signs. By the same token, since acquisition of literacy in the language of the dominant (hearing) culture has perforce been identified by deaf people with achievement of an adequate level of general education, it will be very difficult to challenge the pre-eminence of the dominant language's writing system with some computer system apparently bodged by hearing people! Furthermore deaf communities have survived for centuries as 'oral cultures' (though the epithet 'oral' is ironically inappropriate here) with strong traditions of live story-telling. Any method of making permanent linguistic records poses a direct threat to 'oral cultures'.

It seems unlikely that an orthography for sign language will succeed unless some visionary deaf person picks one up, as Sequoyah did with his syllabary, and runs with it. Moreover, the historical conditions are different; low-cost electronic recording systems were not available to Sequoyah. Although video may itself ultimately threaten live sign language culture (anecdotally, the advent of subtitled television in the Deaf Social Club has at times undermined the social fabric of the club much as a telly in the corner ruins a good pub), it does at least, as an analogue representation, preserve maximum integrity of the language signal with minimum 'tampering'. Videotape technology has many operational limitations in terms of information storage and retrieval, but as we are faced with ever more sophisticated multi-media sytems, we must ask ourselves the question:-

If the ancient Phoenecians had had audio cd-rom, would we have ever had an ABC ?

CHAPTER 8
Music notation

The next two chapters provide an opportunity to compare and contrast two somewhat related forms of symbolic notation. There are some similarities between musical notation and movement notation but also certain differences.

Many ways of recording and communicating ideas have been developed. Most work directly between the recorder and the reader or user. In some there may need to be an interpreter or intermediary. In the case of music, the performer is needed to interpret the composer's creation for the listener. The same applies to movement notation: the dancer is the interpreter when it is used in its original form to record choreographic movement. Of course some musicians may read scores for their own enjoyment, just as Grater points out that some 18th century connoisseurs read gavottes for pleasure.

It is always interesting to look at a subject from another perspective. The process of learning and using a system (here we are talking about symbol systems) is broadening in itself. The tool is then available for thinking, and to manipulate. Taken in an historic perspective, any recording system, whatever its purpose, became more vital in all areas as the facility for memory decreased. So, still further away (very distant from reality in most cultures today), exclusive use of symbolic representation has led to the destruction of memory.

In this case, consider the place that notation has played in the past in enabling the development of both the art of music and dance. It could be argued that the development of music notation enabled ever more complex orchestral compositions to evolve. This function could be said to be mirrored in dance by enabling and encouraging the creation of ever more complex choreography in the confidence of the permanency of the accurate recording details long beyond the original performance (and maybe the precise memory of any particular performer). This means that the artistic delivery is not the end of a creation. First the notater and now a computer base can store for the

With the increasing importance of folk music, experimentation in instrumental and choral expression of music, a need is felt for a more comprehensive notation in India. These illustrations come from a pamphlet prepared by Chimanlais Pvt. Ltd. of Bombay. Their system tries to tackle the problem on the musical as well as the visual front. The categories handled here are pitch, volume, timbre, voice-classification and production technique, word-text, tempo and time cycles. Appropriate symbols have been developed for the different purposes.

future – even transcribing and recording mime, and the individuality of personal gesture.

The differences occur when the actual usage of the two forms of notation under discussion here is taken into consideration. Whereas musical composers usually write out their own scores, building them up through various stages of development, choreographers do not make their own notation. They tend to create with dancers in front of them. The notaters are from a separate skilled profession. They record the choreographer's instructions, altering and developing the score as rehearsals proceed during the creation of an original ballet's complex movements.

The use of the Benesh movement notation by therapists to record the movement details of their patients provides an interesting counter to the cultural tradition usually associated with such notations.

Music notation

The ability to associate sound with meaning arose so early in evolution that it is now innate. Words and speech arose later and need to be learned. We have more or less universal tones for surprise, for instance, anger and humour. These are the same in most cultures, although the words are different. Hence we have a universal music but different languages.

All forms of recording and communicating have been affected in some way by computerisation – most people would say for the better – but in some circumstances compromises have been necessary. These require balancing flexibility and personal expression on one side with general accessibility and convenience on the other. The standardisation and codification that has come about through the increasing mechanisation of music setting, culminating in computer setting, might be compared with the standardisation of spelling, for instance, that came about in England with the invention of printing. Just as then, standardisation has obvious advantages but can mean the loss of local nuances and subtleties. Computer setting might finally erase some of the expressiveness that could be discerned in a hand-written manuscript, and that had managed to survive, to a certain extent, the skilled hand setting of music.

Then there is the matter of spacing – though like so many other typographic features the difference between the setting of a skilled typographer and the computer is noticeable to only a few. In a few more generations there may be no one left to point out that the specially trained human eye could perform better in that particular area, than any computer (as yet invented).

Two people, in different musical fields, have contributed to the subject of music notation. Leslie Ellis, who for many years worked for the music printing company Novello, provides an illustrated outline of the history of the printing of music. He chronicles the transition that brought the specialised craft of music printing from hand to computer setting in a relatively short time and which he experienced during his working life. He discusses the craft of music printing in an eminently practical way. He explains how the apprenticeship for an engraver was five to seven years and that the piecework rate for an engraver in the 18th century was a farthing a note. He also explains that there are 400 characters in a music font, which suggests how skilled and time consuming hand setting was. He talks about the stylistic variations between the great music publishing houses, relating them to clefs and noting, for example, the difference between Novello's own and that of Curwen who used an exclusive design. About spacing, he repeated the printer's golden rule: spacing is done optically, nothing is calculated precisely everything is judged by eye. It is here that the computer has difficulty competing with the experienced human eye – as is also the case in fine typography in other fields, although Ellis testifies that in some cases the appearance of computer setting is so close to engraving that it tests the expert to discern which is which. He wonders to what extent music colleges teach students computer setting techniques or how to mark up their own manuscripts according to the British Standards.

Trevor Harvey briefly discusses the advantages and disadvantages of computerisation for a (relative) amateur and raises issues that apply to many areas as well as to music.

The many ways that music has been created from manuscript to computer graphics

Over the centuries man has devised ways of showing symbols to represent musical sounds. By the time of the invention of typesetting and printing this had reached the form of a staff with five lines as we know it today, although this was not universal and examples of six, seven, eight and nine lines are known to exist.

At first, music was copied by monks and scribes onto parchment or vellum, enabling choristers to follow and sing chants. From the time of the invention of the printing press and the emergence of the printed page, wooden blocks and moveable type were used. Next came typography by double impression, by which the lines were first printed and then the musical notes were superimposed on them. This was superseded by single impression, which had a distinct advantage as the lines and notes were printed from type in one operation. At this time Lute Tablature, the use of letters, numerals and other notation, was also produced from type.

Leslie Ellis was apprenticed as a music engraver and worked for many years for the music publisher Novello as production manager. He oversaw the change over in technology from handsetting of music to computer setting and is admirably qualified to chronicle this advance.

Musices Opusculum: cum
defensione Guidonis
Aretini. *Nicolaus Burtius*
(Italy 1487).
This contains very early
attempts at music printing
from wood blocks.

de of twelue/the thyrde of eyght/the
fourth of .ix. as this fygure sheweth:
❡ Whan these
accordes were
foūdeȳ pictago
ras ȳaf hem na
mes. And so þ
he called iȳ nō
bre double / he
called iȳ sow-
nes Dyapasoȳ.
And þ he called
iȳ nōbre other
halfe he called
iȳ sowne Dya
pente. And þ.þ
iȳ nōbre is cal-
led all ꞇ þ thyr
de dele/hete iȳ sones Dyatesseroȳ/ꞇ
that þ iȳ nombres is called all ꞇ the
eyghteth dele / hete iȳ tewnes double

Policronicon. *Ranulph Higden*
Printed by Wynken de Worde, Westminster 1495.
Single impression.
*This book had only one music example. In printing this, Caxton's pupil and successor
solved the difficulty of 'setting up' the example by putting together the 'quads' and rules
used in his ordinary typography.*

In this booke
is conteyned so muche of the Order of
common prayer as is to be song in
Churches: wherein
are used only these
iiii. sortes of notes,
The first note is a strene note, and is a
breue. The second a square note,
And is a semibreue. The iii. a pyke and
is a mynymme. And when there is a
pryke by the square note that pryke
is halfe as muche as the note, that
goeth before it. The iiii. is
a close, and is only u-
sed at ye end of
a verse.

The booke of common praier noted.
John Merbecke 1550.

Moveable type, Double impression in black and red.
Reprinted William Pickering, 1884.

[90]

This was the laſt Song that Mr. *Purcell* Sett, it being in his Sickneſs.

*From Orpheus
Britannicus
a collection of all
The Choicest Songs
by
Mr Henry Purcell.*

*Printed by
J Heptinstall
for Henry Playford
Temple-Change,
Fleet Street
MDCXV111.
Single impression.*

Music engraving on copper plates started at the end of 16th century and this continued in some countries until 1800. The printing was direct from the plates.

As music became more elaborate and complicated, engraving flourished. Engraving on pewter followed from early 18th century with the introduction of steel punches giving uniformity, again printing direct from the plates. Much later metal blocks, then rubber blocks were in use along with lithography.

In Great Britain typesetting was revived for choral works when they could be set cheaply. In excess of 52 inventors' patents are recorded in the latter part of the 19th century for instruments and ideas to mechanise this unusual industry. Since the 1950s processes including stencils, rubber and metal stamps, music typewriters, acetates (Notaset and Letraset) have been successful and have become part of origination.

Today, however, the computer rules. The first computers used graphplotters for printing out the music This large format had to be reduced. Now personal computers with laser printers and laser typesetters provide same size artwork. Various current music programmes used today are achieving music of publishable quality.

Engraving of music on metal
Copper plate engraving of Parthenia, dated 1611, is recorded as the earliest English example of this type of work.

Twelve Concertos
by A Corelli.
Engraved with the utmost
exactness by Tho. Cross.
Printed for and sold by John
Johnson at the
Harp and Crown, Cheapside.

Pure engraving from the last
page of the volume.

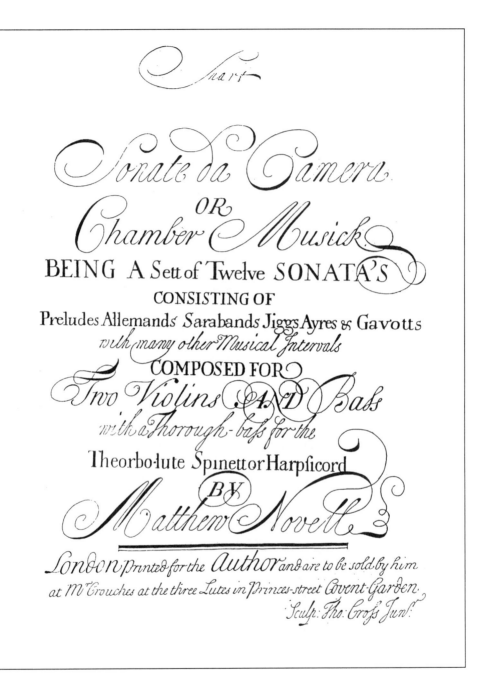

Sonata da Camera *by Matthew Novell.*

Excud: et Sculp: Tho: Cross Junr: 1704.

On it is inscribed 'entirely engraven on copperplates'. By 1680 plate engraving had become general in England. Thomas Cross began engraving about 1683 as his name appeared on Purcell's Sonata of III Parts, signing himself as Thos. Cross Junior, Sculp. His exquisite work was pure hand engraving. When John Walsh commenced issuing similar music aided by steel punches for stamping notes and letters on pewter plates, which were less expensive, Cross engraved on his music sheets ' Beware of ye nonsensicla pucht ones – Cross Sculp. He engraved the title pages as well. The example on p130 shows how elaborate and flourished they could be. Some of the guide marks he used to align the letters can be seen on this title page.

20th century plate engraving
The pewter plate consisted mainly of lead with about 5% tin and antimony and having a thickness of 1mm, the working surface being rolled better than the reverse.

Tools
A **T square** and **straight edge** are the main instruments for aligning and ruling staves and layout.

The **Pin**, a steel pencil-like tool with pointed but rounded ends – is used to mark the music sketch onto each plate and also to draw in any words and their position on the page.

The **Compasses** are important as they are required to space out the music across the page indicating its value by differing widths.

The **Score** is also important as it cuts each stave line. A set of the range of sizes would be in an engraver's kit.

The **single hook** cuts single straight lines and bar lines, continuation lines and brackets.

The **double hook** cuts chorus hooks and thin and thick double lines.

The **striking hammer** is used with all music and text punch stamping.

The **burnisher** aids removing and alteration of errors.

The **busk** takes off a fine layer from the surface to clean off all drawing marks.

The **plannishing hammer** is used to level the surface after
punching in readiness for the cutting stage.

Gravers are the small tools that cut stems, leger lines, ties
slurs cres./dim. into the plate.

A **scraper** is used to finish the surface by removing
blemishes and giving a polished surface.

The method

Before the plates are engraved the manuscript is 'cast off'.
That is, layouts and amounts of music for each system and
page are calculated and marked, usually in pencil, on the
MSS.

All the work on the plate
is done in reverse (mirror
image) to allow the music,
when printed, to appear the
right way round. The
engraver then uses his skill
first to mark on each plate
the vertical lay-down for
staves which are then ruled
by the score in the marked
positions. Burr on the edges
is removed and the plate
cleaned off for the next stage
of marking on to the page

Fig. 1

(fig. 1) a sketch of the music
in abbreviated form. After
spacing the note values
across the stave, this is
repeated with adjustments
until it finally fills the whole
width. Horizontal guide
lines are marked to make
alignment on the staves
correct (fig. 2).

Next the plate is put on a
flat stone and lyrics, time
words and other text are
punched in, the punches
(fig. 3) being hammered

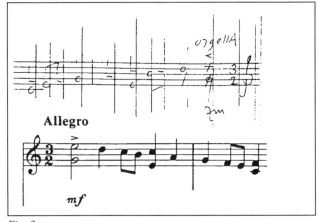

Fig. 2

Fig 3

Fig 4

Fig 5

lightly in position; likewise clefs, accidentals, rests and other miscellaneous signs are added and finally notes, minims and semibreves. The plate is now flattened by hammering on the reverse side with a plannishing hammer. End barlines are cut and the plate is re-scored again.

The cutting stage is reached. Various gravers are used to cut by freehand all stems, legerlines, slurs (fig. 4), ties, cres. and dim. signs and the barlines are ruled and cut using the hook (fig. 5).

To complete the work, the surface is scraped again and the plate re-scored. Now, using his eye for detail, the engraver squares off any damaged corners and touches up ends of staves before finally scraping and polishing the surface. The usual custom of working approximately ten plates, or a movement (section) together helps speed up the completion of the task.

A proof can now be made by applying green ink over the plate with a roller and passing it through a press against a sheet of paper, thus the music appears white on a green background. The pages are now ready for checking by a reader.

When errors are spotted these are removed by punching (pushing) the metal up from the reverse side and hammering flat and rubbing away wrongly engraved symbols.

Music by computer

Early development of computer music came from
programmers in America, Denmark, Japan and Britain. In
Denmark computer development of music for printed
artwork began in 1974 and by 1977 music was produced,
however the quality was poor and needed to be improved.
This was achieved two years later and marketed to leading
publishers with a service of creating and supplying camera
ready artwork from manuscripts.

Many personal computers can now accept the latest
software with input by computer or midi keyboard, so that
composers, musicians, students in education and
freelancers alike can attempt to create their own music
graphics. Software of graphic quality includes Amadeus,
Coda Finale, Nightingale, Score, Sibelius 7 and Toppan
Scannote.

Music and typography

From the time that music was first written down, in medieval times, copyists (the monks and later others who were skilled at translating the symbols), worked at trying to arrange the composer's requirements on the written or printed page in as clear a way as possible. One only has to see the autographed manuscripts of, say, Beethoven or Mozart to see what a challenge this presented.

In later years, when printed music became possible, great publishing houses employed either their own or specialist typesetters for this complex task. Each company developed its own standards for layout. Easy to read and aesthetically pleasing scores resulted. However, these standards were not published, being part of the craft of typesetting that distinguished one publishing house from another.

The advent of computers and in particular PCs has introduced a completely new dimension. For the first time, amateurs who are computer-literate can, providing suitable software is available, produce music scores of good quality. The first major function of all the different packages is to record the actual notes, time values and other data required. Its second function, using rules programmed into the software by the author, is to lay out the music on the printed page. The software writer will have captured a particular set of typesetting standards and used them to produce the desired result. Results will vary according to the quality of the software but usually a satisfactory and professional appearance is given to the score. The better quality packages allow the user enormous variety in placing the musical symbols and text. It is here that the user can have a real impact on the look and feel of a piece of music.

Trevor Harvey stresses 'Personal computers have enabled amateurs to break into an area of printing that has from the beginning been the domain of of the specialist typesetter'. At the same time he warns would-be users of the result of attempting to use their own ideas rather than the default settings. He relates how long it took him (three years and 40 works) before he felt confident to design a layout, and makes a plea for better guides or text books. It is only fair to add that elsewhere in this book it is emphasised that a computer and relevant software do not guarantee good

design or typesetting in any area. Layout is a specific skill, not to be underestimated.

Harvey considers the choice of font to be important, explaining that 'Legibility is all. Many locations for amateur singing are poorly lit. (Professional singers rarely use music on stage anyway or if they do the major concert halls are well illuminated.) Parish churches or village halls are not well known for the quality of their lighting, and the singer will require all his or her concentration to follow the music without having to decipher an unfamiliar font.' Harvey cites an area in which he thinks amateurs and their PCs might make a better job than the professionals. He points out, 'Major publishing houses have often used the title page as advertising space to list all the works of a similar nature which they publish. The result is that in some cases, particularly earlier in the century, the only reference to the title of the work contained in the score was in small print at the very top of a page of closely spaced advertising. An even worse example was the music where the publisher used the same cover for a set of works, and simply underlined or asterisked the particular item in the list on the front page.' Harvey would like title pages to reflect the nature of the music yet he notes, sadly, that this is one area where the software packages have little to contribute.

Once again it is necessary to remind everyone concerned that the computer itself cannot make creative judgements, and designing title pages does not come naturally to every computer operator. Harvey concludes, 'The value to amateur music making however is clear. Composers who may be unable to get their work published by the larger houses can either use this technique themselves or employ one of the growing band of (more expert) PC users to assist. This can only be for the good.'

Younger amateur musicians can also profit relatively effortlessly from modern technology. The following account appeared recently in our local paper: 'A ten-year-old pupil at Sevenoaks County Primary School has composed a new hymn using modern technology... She wrote the music using an electronic keyboard joined to a computer which prints music. The hymn was played in a school assembly and sung by her fellow pupils.' The latest digital pianos,

according to Hewson in *The Times* (28 Jan 1994) look, sound and feel like conventional acoustic instruments but are driven by complex electronic technology and can transpose their keyboard as well.

Hewson also described the opening of a section of the music store Boosey and Hawkes with a PC based booth allowing customers to browse through a CD Rom database of musical scores. Copyrights permitting, they can then have their choice of personalised scores laser printed on the spot.

This computer generated iconography is becoming big business. As a result, people may have the choice of buying their music on disc rather than sheet. This would make a much wider range of scores available as well as making it a simple matter for musicians to 'change songs to suit the singer, a particular instrument or just make a complex arrangement easier by shifting key'.

The Internet provides yet another dimension where scores can be viewed, discussed and eventually downloaded. More comments on the history of music appear in Part 1 on pages 40-1.

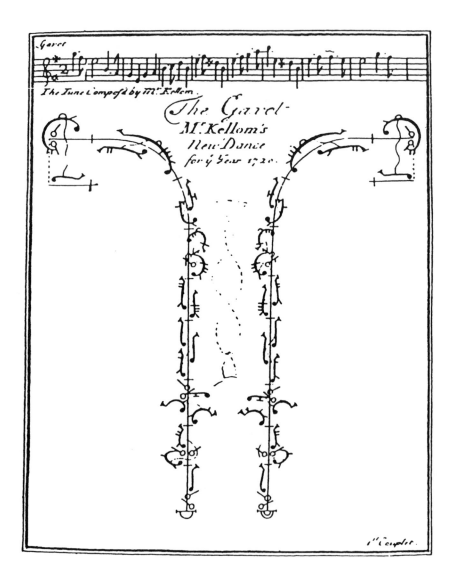

CHAPTER 9

Movement notation

This section is contributed by Adrian Grater of the Benesh Institute of Choreology.

Movement notation is relatively unknown today and, although used to some extent in other fields, such as physiotherapy, its very existence tends to come as a surprise to all but those closely involved with dance. However, it was not always so. Dance notation has been used in one form or another for hundreds of years and in the early 18th century, at what might be considered the height of its popularity, it was not uncommon for members of the educated classes to settle down for an evening to enjoy reading some of the many court dances that had been published in response to the great interest in dance that had arisen from Louis XIV's enthusiasm for the subject. These dances were generally written in 'Feuillet notation' – so called because it had first been published, in 1700, by Raoul Auger Feuillet, although it was almost certainly invented by Pierre Beauchamp, another distinguished dancing master of the period.

Feuillet notation laid symbols depicting the basic elements of the dance along a path representing the dancers' floor patterns, a similar system to that used by Kellom Tomlinson, an English dancing master, when he published the Gavot in 1720.

Dance literacy waned as social dance gradually moved from the great courts to a less well educated general public. There was also a parallel move towards dance as entertainment, which brought with it a different complication: the existing systems, while dealing effectively with the stylised court dances, were too limited in scope to be able to adapt to the new choreographic demands. In the intervening years a number of different systems of dance notation were developed, mostly by choreographers to record their own works (records exist of over 80 different methods). These met with varying degrees of success but it wasn't until well into the 20th century that systems started to develop that were capable of addressing non-dance activities. Movement notation, in its widest sense, had finally arrived.

Figure 1 (full page). The first eight bars of the Gavot, from Kellom Tomlinson's 'The Art of Dancing and Six Dances', 1720.

It is generally recognised that three methods now predominate, each named after its originator/s – Labanotation (Rudolf von Laban, first published 1928), Benesh Movement Notation (Rudolf and Joan Benesh, 1956) and Eshkol-Wachmann Movement Notation (Noa Eshkol and Abraham Wachmann, 1958). Interestingly, each system uses an entirely different approach and style of graphics, which can be clearly seen in the following recordings. For the purpose of further comparison, these are of the first section of the movement sequence already illustrated in the 18th century notation of Figure 1.

2a) Labanotation

'...our movement notation is based on the elementary motor principles of the human body'. Rudolf von Laban, *Laban's Principles of Dance & Movement Notation* (London, MacDonald & Evans, 1956).

Labanotation is read from the bottom to the top of the page. Information about support and leg movements are written in the two central vertical columns; the next columns, working symmetrically outwards , contain information about the body, arms and hands, with a further column at the right for the head. The signs placed in these columns vary in shape according to direction, in shading according to level and in length according to duration.

2b) Eshkol-Wachmann movement notation

'The field of interest of this notation is the formal aspect of movement... it is therefore of no relevance for its construction and use to know why... a movement is performed' Noa Eshkol & Abraham Wachmann, *Movement Notation* (Weidenfeld and Nicholson, 1958).

Eshkol-Wachmann notation is read from left to right, with separate horizontal columns for the different body parts – in this recording these are, from top to bottom, the left arm, right arm, upper body, right leg, left leg and front (direction faced). The columns are divided

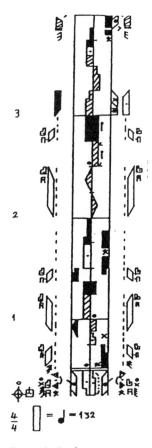

Figure 2. On these two pages are the first three bars of Tomlinson's Gavot recorded in a) Labanotation (above), b) Eshkol-Wachmann Movement Notation and c) Benesh Movement Notation.

b) Eshkol-Wachmann Movement Notation

into time units, into which are placed symbols representing the type of movement (rotation, conical or planar) and its direction (positive or negative), together with numerals to represent the static orientation and/or range of movement.

2c) Benesh Movement Notation

'...since we are dealing with a visual art, it had to be based upon what is actually seen, just as our spoken language requires a phonetic notation and music an aural one.' Rudolf Benesh, *An Introduction to Benesh Dance Notation* (A. & C. Black, 1956).

c) Benesh Movement Notation.

Benesh Movement Notation is read from left to right and takes the form of a series of 'frames' of abstracted figures placed along the horizontal five-lined stave. The

stave lines identify the height of the top of the head, the shoulders, waist and knees respectively, with the bottom line representing the floor. Signs are placed in each frame to correspond to the location of the body parts to which they refer. Timing is given by labelling frames with rhythm signs as necessary.

Creating the dance score

As playwrights write their own plays, novelists their own novels and composers their own music it would be reasonable to assume that choreographers write their own choreography. However, this would be an entirely false assumption. Instead, most choreography is created upon the moving body, being constantly adapted and changed by the choreographer in response to what he sees before him, and it is the job of the notator to observe this process and produce a script that represents the choreographer's final intention. This often isn't 'fixed' until the work is performed and, as it is inevitably the result of an evolutionary creative process, the notator will ideally not only need to keep records of each stage in the process, for later reference, but will also need to update the record on a day-to-day basis for it to remain practical and legible.

Computerisation

As can be imagined, the process outlined above would be helped immensely if each stage could be computer-edited and archived and the final score created by electronically cutting and pasting amongst these records rather than by erasing and re-writing by hand at each stage. However, unlike text, mathematics and music notations, movement notation had remained more or less entirely dependent on pencil and paper until the last decade. Some token efforts had been made in the 70s towards easing the writing process by adding the signs and symbols to typewriter 'golf-balls', but these had proved to be of such limited practical value that they never challenged the traditional methods.

The comparatively restricted use of the notation made commercial development unviable and it wasn't until the 1980s, when university computer departments saw

potential for research, that the possibility of developing more sophisticated writing methods became a reality. Research focused on two main areas: the use of movement notation in the context of computer animation and the design of software for writing and editing notation scores. It is the latter process that is discussed here, specifically in relation to the computerisation of Benesh Movement Notation that has been carried out under the auspices of the University of Waterloo, Canada. Before discussing this process it would perhaps be helpful to know a little more about the way the Benesh system functions.

Basic structure of Benesh Movement Notation
The notation is able to convey three-dimensional information by using different signs for plotting limbs depending on whether they are level with the body, in front of the body or behind the body:

— | •

– basic signs for hands or feet level, in front and behind the body:

⊢ ✝ ✕

– basic signs for bent elbows or knees level in front, and behind the body:

When these signs are placed in the frame at the precise height and span of the extremities or joints, a complete 'picture' emerges – it is unnecessary physically to draw in the line of the arm or leg, etc. as this is already given by the existing abstracted information. Further signs and symbols are added as necessary for positions of the head and body, wrist and ankle, finger, eyebrow, etc. Intermediary movement can be shown by 'movement lines', which effectively provide a trace of the path in space that a limb has taken to arrive at any given position. Transitions, such as steps and jumps, are shown by locomotion lines which link the movements from one frame to the next, and further signs are used to show direction faced, location within a given area, detail of timing, etc.

An idea of how pieces of information gradually build up to give a complete picture of a movement can be gathered by looking below at the way in which different signs have

been added to create this single frame from the score of
Tomlinson's Gavot (Figure 3)

a) b) c) d) e)

f) g) h) i) j)

Figure 3.
a) A low step forward onto the ball of the left foot
b) The torso is rotated towards the left, the head
 counter-rotated right.
c) The right hand is in front at shoulder height:
d) – having 'unfolded' from a position below the
 waist
e) – with the wrist facing inwards
f) – and flexed forward slightly
g) – having performed a 'half circle' clockwise.
h) The left hand is level with the body at waist
 height:
i) – with the wrist facing upward
j) – having performed a 'half circle' anti-clockwise.

Practical considerations of the software design

As the notators would need to continue to use traditional
writing methods as well as those provided by the new
technology, it was recognised that the software would need
to be designed to be sympathetic with the way in which
notators already thought about and used the notation.
There would be no chance of success, for example, if the
notator had to spend part of the day writing signs in
pencil, without conscious effort, at any place on the stave
and then had to spend the other part of the day using
'foreign' keyboard instructions to type each sign followed
by further keyboard instructions to manoeuvre it to its
precise position. If the software was going to be used it had
to be as compatible as possible with existing working
practice.

This problem was greatly eased by the appearance of the
Apple Macintosh computer which was just starting to
become available at the time, with its 'mouse' more or less
eliminating the need for keyboard use and providing just the

flexibility that was required. The potential was there for the signs to be selected and placed anywhere in the score in a single move. But of course there was much work to be done before this could become a reality. Amongst the first questions that the computer team asked were:

 – how many signs?

 – what are their precise shapes and sizes?

Such obvious questions proved very difficult to answer because the notation had never been fully documented.

Number of signs

The problem here can easily be related to a spoken language. For example, English-speaking people know that there are 26 letters in the alphabet but none could tell you either how many words they themselves could make from them nor how many words the 26 letters can make in total (the latter, of course, is hypothetical as the nature of language means that the number is constantly changing). But what is more to the point is that there is no actual need for them to know this, as all they require are enough words to be able to communicate efficiently. However, it would be a different matter if, for example, they wanted to write a computer program that could check the spelling of their personal vocabulary, as to do so it would have to be defined. This was rather similar to the position that the research team found itself in, dealing with a system of notation that uses a limited number of basic signs which combine in an as yet unquantified number of ways to give different shades of meaning, for example:

i) — = a 'level' sign (see earlier)

ii) | = a 'front' sign (see earlier)

iii) — = two 'level' signs joined together (two feet together)

iv) ⊣ = iii) with a 'front' sign added to show the right foot closing in front of the left

v) ⊢⊣ = iv) with a 'front' sign added to show that the whole action is occurring in front of the body

vi) ⊣⊢ = v) with a 'front' sign added to show that the
right foot is only slightly plantarflexed
(stretched forward)

vii) ⊣⊢ = vi) with a 'front' sign added to show that the
left foot is fully plantarflexed

viii) ⊣⊢ = vii) but tilted to show that the right foot is
slightly higher than the left, etc

The signs shown in examples vi), vii) and viii) had never
been seen before but revealed themselves in the process of
documentation. They had never been seen because the
occasion for their use had never arisen – i.e. the unlikely
actions they represent had never needed to be recorded.
However, their meaning was clear because they arose from
logical combinations of signs in common use and therefore,
they had always existed! This had the effect of changing
what, to the notator, appears to be a very small number of
signs into a staggering total for the computer. An example
of this is that the computer identifies over a thousand
different combinations of signs for 'two feet together' which
all arise from selective use of just five signs (the three basic
signs already described plus the contact sign (∕) and the
'closing behind' sign (o).

Another question that followed on from the identification
of signs was that of how to make them available to the user
– in what groupings and in what quantities? This was fairly
easily solved because, while it might have been tempting for
a programmer to group together all the vertical lines, all the
diagonal lines, etc. this would have been completely at odds
with the way in which the notator thinks. They were
therefore grouped together according to their semantics –
i.e. all the signs for movements of the head and body were
grouped together; all those for directions and turns; all
those for timing, etc.

However, this proved rather problematic in some
groupings due to the sheer number of signs and
combinations that had to be dealt with. It was clear that, to
be efficient in use, the computer would have to limit the
number of choices being displayed on the screen at any one

time, otherwise the user would be spending too long a time searching for the one that was needed and there would also be insufficient space left on screen for the display of the score.

This was solved in most cases by showing only a basic selection on screen but that can be triggered to change shape according to specific instructions. To use the basic signs as an example: depending upon where the extremity or joint is to be plotted, the signs may be used as already illustrated or they may need to be 'crossed out' with a left diagonal stroke, a right diagonal stroke or both strokes. The computer therefore needs to provide three variants of each of the six basic signs which, together with a set of three 'replacement' signs and their variants, total 36 different shapes – too large a group to be ergonomically efficient when displayed together. They are therefore shown merely as the basic group of nine signs but with trigger boxes which make the whole display change to the selected option, as shown in Figure 4. This not only mimics the way in which the notator has been accustomed to thinking about the signs (think of the sign and then cross it out) but also optimises screen space and user efficiency.

Figure 4. The Benesh Notation Editor's current menu box for the basic 'limb' signs in its four different guises

a) b) c) d)

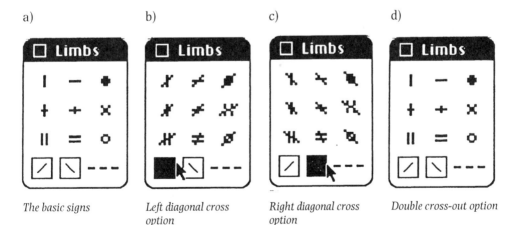

The basic signs

Left diagonal cross option

Right diagonal cross option

Double cross-out option

Sign dimensions

Considerations of sign size and thickness have always been based on the need for clarity of sign (and therefore of information), not only in the original document but also in first and second generation photocopies – a crucial consideration to ensure that a stray crumb on the copier does not distort the choreography! There were, of course, some practical 'ground rules' to help clarity – such as to create the more visually discernible acute, rather than obtuse, angles when combining different signs (for example to combine — and ⟋ to make ⟶ rather than ⟍) but these were of little help to the computer, which needed precise angles rather than the generalisations that had always served notators so well. Furthermore, it needed this data in two forms – firstly for the screen display which, owing to the screen's physical characteristics, is rather crude (see Figure 4), and secondly in very precise terms for the laser printer.

The fact that there are recognised experts in the analysis of handwriting is evidence of the uniqueness of individual draughtsmanship, a diversity that is reflected in the constant stream of different fonts that the market provides for computerised text. Happily, although there is also a great deal of individuality in hand-written notation, only one 'font' was required for the computer editor, although it had to be one that would be acceptable to all users. The font was therefore based on an analysis of the autography of some notators who were generally acknowledged in the field as having a particularly 'good hand'. While there were differences in the length and angle of the individually hand-drawn signs, it was found that there was little variety in their thickness as most notators still use the 0.35mm and 0.5mm pencil leads that are recommended to them when they learn the system! (It should be added that these are not replicated by the computer, which uses much finer lines when appropriate).

The results can be seen in the following illustration, which shows the computer-notated frame illustrated earlier in Figure 3 beside three different hand-drawn versions of the same notation.

a)

b)

Figure 5. A frame from the Gavot a) mastered by hand by three different people and b) computer drawn.

Comparisons of time are interesting:

a) hand-drawn versions: 50 secs. to 1min. 30secs.

b) computer version: 1 min. 45secs.

However, the computer comes into its own when performing the editing function for which it was designed as it would only take about five seconds to reproduce the frame elsewhere in the score whereas each of the hand-drawn versions would take as long to repeat as they took to draw in the first place. Furthermore, the differences in time between writing in the two methods is, in fact, rather exaggerated in this example as the small 'turn' signs added for each hand are not currently available in the computer as single units and therefore have to be tailor-made. The times would therefore normally be much more compatible, as longer sequences would include other elements that favour the computer, such as the long curved lines that need only a simple action in the computer but the assistance of other writing implements, such as flexible rulers, when hand-mastering.

Another factor that has to be considered is the spacing of the notation along the stave. It will not matter in a rough draft score if the stave is filled to the end – even less if it finishes tidily with a vertical bar line. However, when writing the master score, the notator has to calculate the spacing very precisely along the whole stave line before starting to write anything in it, to ensure a full stave and, wherever physically possible, a closing bar line. The time spent on this is eliminated when using the computer, as it has a sophisticated in-built procedure for dealing automatically with both these requirements.

In this final illustration, which is of the opening of the boy's solo from the 'Peasant pas de deux' from *Giselle*, it can be seen that the notation has been spaced too widely in the rough score to provide a 'tidy' end to the stave, whereas in both the master score and the computerised score this has

been achieved by tightening the spacing along the line, albeit in slightly different ways. It can also be seen that this longer passage has brought the time required for hand-mastering and computer notating much closer together.

Figure 6. The opening of the Boy's Solo from the Peasant Pas de Deux from Act I of Giselle.

a) Rough draft score (writing time approximately 3 minutes)

b) Hand-drawn master score (writing time approximately 10 minutes)

c) Computer score (writing time approximately 14 minutes)

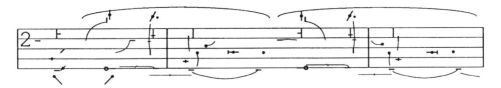

The next stage in the computerisation of Benesh Movement Notation is to develop a formatting process that enables two or more staves to be linked together, with simultaneously occurring action being automatically placed in vertical alignment (this can be compared with the way in which music scores link the bass and treble staves in piano scores or link the staves of all the instruments in orchestral scores). The possibility also exists of getting computers to 'read' the movement notation score and to display the moving figures on the screen. But this is another story....

On spacing

Adrian Grater says about spacing that it is still a struggle to get that algorithm into the computer. The development continues as a dialogue between programmer and the pros who use the notation. He believes in allowing the notator to overrule any instruction, otherwise, as he says, 'they complain that they feel restricted, their hands are tied and the freedom that the pencil provided has gone'. This seems to me the vital balance between efficiency and personal choice that is so often absent in other programs, and in their very philosophy. These programs, like those for much desk top publishing, seem to suggest that a few unalterable rules are sufficient for typographic layout. The most cogent argument for efficiency (or economy) seems to be that of being able to employ inexperienced people and save money. It is to be hoped that education will halt this slide before there is no one left to show what a skilled typographer can achieve.

Movement notation for clinicians

This section is written by Helen Atkinson who is a lecturer in physiotherapy at the University of Coventry.

Benesh Movement Notation is a written language of movement which can be applied to any human movement – normal or abnormal. It has great value to clinicians such as physiotherapists, podiatrists and occupational therapists as well as to ergonomists. The basics of the language applied to clinical work, and the signs used, are the same as those for dance, but because of the needs of the clinician to analyse the faults in the patterns of movement used by the disabled person or the pattern imposed by unsuitable work stations, it is important that the notation clearly spells out any deviation from the normal. Thus, where the notation of dance may be able to assume certain movements to be conditioned by the body mechanics of the flexible human being, this cannot always be assumed when dealing with the disabled or disadvantaged worker. To facilitate a full analysis of the written material more signs are sometimes used than would be necessary in other circumstances. The simple example of clinical notation on the following page demonstrates this and indicates how the notation can be manipulated to serve whatever circumstances demand of it.

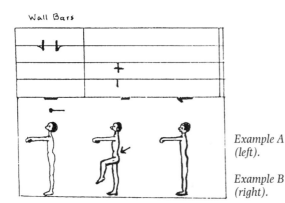

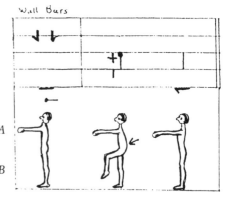

Example A (left).

Example B (right).

In practice many combinations of signs are used and each one is specifically placed on, or close to, the five stave lines to clarify the relationship of one part of the body to another. Because of the relationship of one part of the precision of the notation, the observational and analytical skills of the notator become sharpened and the ability to extract information from the data develops with experience. This has been seen to be a 'spin off' effect of teaching even the very basics of the notation to physiotherapy students.

Although a handful of physiotherapists in the UK have become advanced notators, they have not yet managed to persuade a sufficient number of their colleagues to study the skill in order to make it a viable communication tool within the profession. Until it is taught as a basic communication skill to undergraduates, physiotherapists in this country will remain 'illiterate' as far as notation is concerned and will not be able to reap the benefit of this invaluable tool. However, clinicians in Japan have become very interested and have undertaken the courses offered in this country in order to become proficient. The personnel have included physiotherapists, occupational therapists and two medical practicioners from Japan who have been sent from the University of Nagasaki to Coventry University. They have undertaken the modular course offered to clinicians and validated by the Coventry University in conjunction with the Chartered Society of Physiotherapy Postregistration Education Committee.

In order to encourage their students to become interested in the notation, a special course for academic and clinical educators has been developed and validated. This has been

Example A illustrates normal movement available in the left hip joint. The left knee has been raised forwards and flexed, giving movement at the hip joint without causing the need for for any compensatory action within the vertebral column or right hip joint because the range of movement available at the left hip joint allows freedom of movement to this degree. The figurines under the notation are present to permit the uninitiated reader to picture the movement.

Example B illustrates limited movement available in the left hip joint. The individual is attempting to achieve the same action as A but, because the range of movement in the left hip joint is very limited the knee can only reach the same height by the compensatory action of the spine and right hip joint. The clinician would be able to obtain the information that the lumbar spine has compensated by flexing in response to a posterior tilt of the pelvis and that the hip joint has contributed to this compensation by allowing maximum extension to occur.

This apparently gives the same effect as in A, but the pelvis has had to tilt posteriorly in order to achieve this effect. A careful look at the figurine illustrating what the notation is saying will show the altered position of the spine and the angle of the pelvis. Thus, from one line of notation the clinician can compare the action of a subject with normal movement with that of a disabled subject. The notation high-lights the difference in performance, leaving the clinician to analyse the cause. In the example given above the cause of limitation of range of active movement could be due to muscular weakness, incoordination, true joint impairment or a combination of these. Subsequent examination of the subject would enable an accurate conclusion to be reached.

constructed to introduce the basic concepts by distance learning in order to minimise the need for leave of absence to study. The practical applications of the notation have been arranged to occur during a Summer School attendance, lasting for ten days. Whilst this will not produce advance notators, it will give educators an insight into the concepts and potential of the notation. However, to date, no one in the UK has expressed an interest in the course. This is of some concern to the few who have studied the notation since it is feared that it will be lost to the clinical professions unless it becomes part of the undergraduate curriculum.

Apart from being applicable to the recording of assessment of functional abilities of disabled people, the notation proves its worth in the clarity of presentation of research papers in which functional movements have to be described. Although all therapists have well developed observational skills very few are able to write down what they have observed in a clear and concise manner, which is unambiguous and not tedious to read! One stave of notation can replace many pages of 'long hand' written material. Only a few of us are linguists, and only the best artists can give a three dimensional figure with any accuracy.

In the past, Ling terminology has been used by therapists in an attempt to communicate movement details. This was originally developed to describe specific exercises, is very limited in its scope to describe functional movement and it has fallen into disuse for this reason. To compound the situation, some specialists within their own field have methods of describing movement which they have devised within their own specific interest groups. These are peculiar to that group and are not available to clinicians in general.

A common international language for general use is essential to world wide communication of information – preferably computer generated. Benesh Movement Notation is an international written language of movement in the same way as is written music. It is moving strongly towards full computerisation and, if our therapists and other workers are to maintain the role of leadership which they have taken up in other fields of their work, they need to look carefully at this tool before discarding it for another which may be less versatile in the long runand may take years to develop.

Title screen for the ARC. These screens are visually weak when reproduced on paper, yet strong as a new media screen image.

Title Screen for the ARC with all navigational icons visible. These icons are normally visible as individual icons when rolled over by the pointer tool.

CHAPTER 10

The way forward

What of the future? How important will individual icons or entire symbol systems be in a world linked ever increasingly by computer networks such as the World Wide Web (WWW) that are impervious to national boundaries? As writers have stressed in their own ways in various chapters of this book, not all are linguists, able to interpret whatever language a correspondent chooses to use, and not all are artists capable of designing icons that will be immediately recognisable to others in their own, much less those in different cultures. It seems not only that the possibilities are endless but that it is vital to put resources into an area which will be of benefit to so many.

Under the title *The Icon Revolution*, Gunther Kress (1995) proclaims: 'While Gutenburg's revolution made language in its written form central, the current revolution is taking us both backwards and forwards into hieroglyphics. Whether this is in the introduction of *emoticons* through the exploitation of the visual potential of typographic elements, or the proliferation of the use of icons in so-called written texts, or indeed in the treatment of (verbal) text itself as merely an item in a visual composition, in new-modal, multi-media form of text, what is happening is a fundamental challenge to the hitherto unchallenged cultural centrality of written language.'

'Indeed,' writes Honeywill who has contributed much of this chapter, 'the need for mediated human-computer-human interaction challenges the centrality of written language. But, is it possible to construct a writing system out of symbols that have no necessary connection with language (Sampson, 1985)? History informs us that hieroglyphic writing first appeared in the Nile Valley about 3100 BC and did not change in its essential logographic form until its decline through external influences. This Egyptian method survived 3400 years of use, longer than any alphabet system.

It was free from ambiguity, with only a small percentage

of the 2500 individual signs in common use. For new
foreign additions to the language, monoconsonant signs
could be used; multiconsonant signs could be reinforced by
phonetic complements drawn from monoconsonants, and
other such components would be added which confirm the
sign as a logogram or plural and so on. Other hieroglyphic
systems, such as the Maya, developed independently of any
'old world' influence, yet, like the Egyptian system,
contained a mix of logographic and visual phonetic
components. This system also utilised a smaller percentage
of glyphic elements rather than the full array, which would
have been available to the scribe. In a glyph for glyph
showdown the Maya writing contained fewer components
than the Egyptian system, thus the Maya encoders and
decoders had less to learn. To construct a visual writing
system that is not linked to any particular language, with
unambiguous usage, would enable mediated human-
computer-human interaction across national boundaries,
but, should this be more than encapsulated concepts? We
should indeed look back to look forward.

The Maya had a fixed lexicon of components which were
mixed to describe each situation. At present, icons are
developed arbitrarily to represent each new situation. It is
only email that has devised a fixed emoticon lexicon
through the confines of the keyboard, the proximity of the
screen and the inability of email software to convey
typographical expression. Unlike the nuances of typography
that can give a message added value according to the choice
of typeface, size and weight, email can only express itself
through the interplay of upper and lower case within a fixed
size and font. Indeed, the use of uppercase is deemed to be
'shouting' at the message receiver. By being confined to the
keyboard, emoticons have become standardised, understood
and regularly used within email to convey the emotion of
the message sender :-) Basic happy :-(Basic sad. Simpler
emoticons are self explaining, while other, more complex
icons require a learning investment for both encoder and
decoder {:V (duck). This combination of expression is
confined to the lexicon available from the keyboard; there
are approximately 120 emoticon combinations which can
be combined with a phonetic alphabet.

What can we learn from a closed system? Emoticons have developed naturally through the need for further expression. What lessons from history could impact upon the Graphical User Interface? Maya hieroglyhs developed naturally using a mixed system either to encapsulate a concept or phonetically to spell out the message. Can a visual language, which has boundaries, have the flexibility to meet the demands of any new situation?'

Designing icons for the screen

The working methodology of the designers who develop any corporate identity know that they are encapsulating the message of an organisation. Traditionally, the designer works with movable paper graphic components within a grid architecture to establish the aesthetic relationships for the wholeness of the symbol. It is this paper grid that allows us the visual leap to an icon designed for the computer icon 32x32 pixel matrix. To design icons as part of a family, with each symbol conveying a different message, requires an extension of the first to ensure visual harmony across the range. The design process has to be executed across a broad front and if one symbol within the family fails then adjustments will have to be made for part or all of the range.

The Maya scribes could have written everything in their language phonetically. They chose not to; the Maya system allowed the scribe to be:

- Graphically clear – selected from a refined closed system
- Semantically unambiguous – through a mix of visual writing
- Adaptable – interchangable parts which can express meaning
- Simple – within a glyph block (see also p159)

Obviously the phoneticism of the Maya has linguistic bias and reflects their culture. However, their system did allow the scribe to set the tone of the message through a graphically refined visual writing. Like any picture, it is not what is included within an image, it is what the artist leaves out which enhances the readability of the message. Indeed, because the system was also closed the scribe could

Balam

ba Balam

Balam

m(a)

ba Balam

m(a)

ba la

 m(a)

Alternative ways of writing jaguar, 'balam'. Depending on the tone of the message, the scribe could visually write lographically, phonetically or mixed. Reproduced from Coe (1992)

interchange components (graphemes) within glyphs, not unlike the construction of Aicher's 'body alphabet'. The difference with the Maya system is that it contained sufficient graphic components to convey an overall concept or a precise phonetic description or a mixture of both. The rich imagery of the Maya system therefore functioned as both visual and written language but the expression of the individual artist had to be tempered by the necessity to communicate, conforming to the system. Because of this need for communication, Maya iconography had to be conservative; however, as with typography, certain artistic variation in style was also used.

To the scribes of the hieroglyphic systems of the Nile Valley and Mesoamerican, visual writing was explicit to their language and culture. To the designers of the computer icon, the convergence of technology between computers and communication can only be implicit visual language. This is because computer users at any geographical location can communicate words, sounds and images normally through a shared iconic interface. With international barriers digitally removed, encoders and decoders are separated only by linguistic and cultural differences.

Frutiger (1989) argued that typography should have subtle nuances and it is this which has allowed typography to evolve. 'You may ask why so many different typefaces. They all serve the same purpose but they express man's diversity. I once saw a list of Médoc wines all of the same year. All of them were wines but each was different from the others. It's the nuances that are important.' In the same way, any closed iconic system should have visual variation and adaption to changed cultural relevance, yet leaving the message unchanged.

Design for the screen should be approached by combining many of the skills that have been mentioned in this book. The designer of the printed page makes rough sketches on paper before committing the design to the computer. Screen design merely extends this to include transition from screen-to-screen, mapping interactivity, moving images, sound and so on. We have learned to turn the pages of a book; we are now required to navigate through non-linear computer networks, interacting with other cultures and their

Language can progress from ideographic to phonetic, or towards greater utility. Repeat patterns, such as the infixed hand, can be recognised independently of specific language. Appropriate components survive through their ability to be unambiguous, simplistic and adaptable. All are single applications icons except the Remote Accession (bottom). This icon represents several European locations using the files and applications of one computer viz ISDN. The hand application infix has adapted its meaning.

*The interface and
navigational iconography for
the University of Plymouth,
Faculty of Technology
CD-ROM.
Courtesy of MediaLab Arts,
(1996).*

perception of meaning. Paper based design has developed
and refined over a long period. It is these lessons of good
practice, together with an understanding of the factors
which impact upon the global message receiver, that should
be adopted, adapted and applied to iconic screen design.

Design considerations for a visual language

To designers and those who educate designers the
implications are significant. Developing a visual language
will entail not just projecting the designers' personal
concepts into symbols. Thorough, analytical research into
the entire background of potential users will be needed.

Mealing and Yazdani (1990) present design
considerations for a visual language. Their criteria for icons
are that they should be:

- Graphically clear
- Semantically unambiguous
- Without linguistic bias (culture, race?)
- Adaptable (open to modification to express shades of
 meaning)
- Simple (perhaps created within a 32 x 32 pixel matrix)

This work was undertaken in a simple computational
environment in order that the ideas may have a wider
application. However, it is anticipated that as a consequence
of a natural development of visual language, additional
design aids may be used, including:

- Colour
- Movement (micons)
- Background (picons)
- 3-Dimensional (CAD style space of 3D icons)

Iconic communication systems may use icons that represent
units of meaning greater than single concepts. In return the
icons can explain themselves if need in order to clarify the
meaning and provide the context. An icon should be able to
explain its meaning:

- in terms of more fundamental icons
- trace its development from representational pictorial
 reference
- maybe even through natural language.

Such 'self explaining icons' can be simple animations to help the user understand the meaning of the message clearly and thus avoid the problem of ambiguity associated with static icons. This approach can be seen as an attempt to add computer animation to the work of the Isotype movement. Isotype has attempted to avoid ambiguity and complexity of natural language. The Isotype rules for creating new icons can be incorporated into a visual language and extended. New icons therefore may be produced by:

- Superimposition
- Conjunction
- Concatenation
- Transformation
- Inheritance
- Duplication

The Atlantis InterArc research programme

The Atlantis programme has allowed investigation into some of the most difficult aspects of coordinating collaborative practice projects via digital networks between remote sites. Human face-to-face interaction is removed as an option because of the European geographical location of the participants. Each site was expected to contribute to the development of an interactive new media digital equivalent of a journal, and this raised some important questions. Is text an appropriate place for a new media? Does the published word belong to paper? If phonetic language systems have to be learned, is the development of an electronic journal, new media 'thing' or 'what', appropriate to a mixed linguistic user group? What can we learn from the history of visual language? By removing any linguistic underpinning do we maintain parity of use, and therefore, enable our partners to have full access?

With all linguistic underpinning removed our understanding is confined to the barriers of cultural familiarity. If we consider the Maya hieroglyphic system, it is not the Maya language that was the key to its

The following (Honeywill et. al., 1995) is an extract from the Atlantis InterArc 1995 research programme and explores the convergence of technology from computers and communication and the natural development of a computer iconic language specific to a defined European user group, when a cognitive investment is required to learn an iconic system through the intended removal of all phonetic under-pinning. The full article can be found on the Internet at: http://www.dcs.exeter.ac.uk /~masoud/yazdani/friend/ honeywil.htm

The hand that covers the disc, 'completion of the sun', chikin, 'west'. Reproduced from Coe, (1992).

Stills button. On mouse-up this icon remains static.

Interactive button. On mouse-up this icon becomes motion dynamic.

Stills from the same self-explaining, motion and sound dynamic icon.

decipherment, but its structure. If we understand the cultural values in which a system is used, we can in part decipher the message. However, unlike the iconography of the computer interface where the icon is labelled separately, the Maya system was a mix of logograms underpinned by visual phonetics which were encapsulated within the hieroglyph compound. Brinton (1886) identified the directional glyph for 'sunset' or 'west' as the hand that covers the disc, and that the combination should be read as 'completion of the sun', *chikin*. Coe (1992) phonetically reads the hand as the sound *chi*, placed above the logogram *kin*, and therefore reads 'west'.

Rather than being phonetically explicit, testing the cultural equivalent of the concept for 'completion of the sun' was deemed more appropriate for evaluation purposes. It was decided that the media would be an interactive compact disc entitled, *Arts Research into Communications* (ARC). Therefore, the ARC was to develop and test methods of information exchange, and to evaluate methods of visual communication within a group which has approximately the same cultural values. It was also decided that the ARC would not contain written text for the opening title or home screen. Lack of text meant that communication would be through various types of icons, from representational to abstract (Stammers and Buckley, 1992).

User interaction was assessed when one category of abstract icons closely resembled another, yet each icon changed from static to motion dynamic depending on its intended use on 'mouse-up' as previously stated by Mealing and Yazdani (1994). When launched it is evident what the intended use of each icon is. The second set of icons is closer to being representational and therefore, the icons are independent of each other. The representational icons were to be aligned on the home screen, while the abstract icons were to be clustered. This would challenge the user, first to identify certain navigational interaction points according to category, and second, to identify the user investment time in learning a navigational system unique to a specified group. Forcing the user into cognitive investment is important if the ARC is to track and monitor the time it takes to learn a system or, indeed, at what point a user simply gives up.

The title screen of the ARC has four hidden 'roll over' navigation points; all are visible on mouse-up and each individual icon is visible on roll over. The four hidden roll over icons on both the title and home screen remain constant throughout the CD. Once their position and function has been learned the user can always expect to find them at these navigational points. The advantage of this is that the content is not cluttered with icons, leaving

Home Screen with the still button up on roll over.

(Screen images: Duncan Wilson, Fine Art, University of Plymouth).

Home screen showing all navigational points. The top aligned row shows representational icons. Abstract icons are closely clustered together on the screen.

These different sets of icons allow for the 'behind screen' tracking and monitoring to report back user learning, preferences and so on.

Navigational icons are only apparent on roll over. Once their meaning is understood the user will expect to find them at these points throughout the ARC, leaving the screen uncluttered.

(Screen image, Louise Maciver, Fine Art, Cardiff Institute).

the graphical user interface clear to preform the functions of the ARC's content.

During the developmental phase linguistic problems soon became apparent. Even though technological parity for all sites was the same, the communication between the United Kingdom sites varied when the link was between the United Kingdom and France or Spain. Simultaneous voice and computer communication between the United Kingdom, France and Spain soon became screen shared computer-only communication. Most 'real-time' communication took place through the 'note pad' on the Apple pull down menu. Initially, the note pad was only recognisable for its culturally familiar shared icon between the United Kingdom and Europe. Even the position of the note pad was different for the European locations because of the spelling of 'Calepin', and subsequent alphabetical positioning within the Apple pull down menu.

Unlike shared screen telematic or telephonic communication, shared screen only exchanges allow for the interplay of the note pad and the use of images launched or dragged onto the computer screen. Human-computer-human interaction removes physical contact, the need for expression facilitates elaborate on screen iconic representation. One such exchange probably took several hours to develop, flashing graphic representations to enforce the message, moving the eye systematically around the screen and moving the mouth in a gesture of speech – all are vital components of this mediated conversation. The message was – how do you adjust the volume within the Director Lingo Script? Convergence of technology also leads to new working methodology; it requires a knowledge of multimedia authorship, publishing, graphic design and media production skills. Combined it can either supplement or surpass conventional communication.

A prototype for an interactive iconic hotel booking system

This project has allowed researchers to apply iconic language into a simple dialogue – where the system has fixed iconic values and uses. The developers have assumed no interaction would take place between hotel and customer during the compilation of the message and its reply. Booking the hotel and its facilities is accomplished in stages, and at each stage the current domain is cued by a picture resident in the background. When dealing with the required room type(s) the background image on screen would be considered the norm for a room. Sub-domains require a typical bathroom, dining room area and so on.

The prototype was developed using standardised graphic iconography as a schematic framework. Once the interactive structure has been developed the final visual research will allow for the deployment of a closed semasiographic iconic language. The first screen shows a typical hotel overlaid by an appropriate caption (here phonetic underpinning has been used), and clicking anywhere on the image starts the booking sequence.

Throughout the application, the user is presented with a limited range of choices at any one time. The features are selected by clicking on the relevant icon, which produces a

This is an extract from a prototype hotel booking system developed by Yazdani and Mealing (1995). It uses icons to allow a potential guest and hotel manager to communicate. The system is an initial attempt to create an interactive, iconic dialogue using hotel booking as a theme. This prototype system would allow a user to compose his complete booking requirement iconically and send the message to the hotel manager to reply to (again iconically). The design of the system has been divided into two independent stages of composition and comprehension.

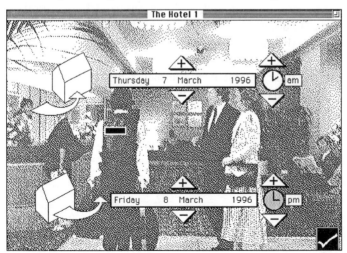

This is the 2nd screen in the booking sequence. The user would have already selected destination and star rating. Here the user selects dates and times of arrival and departure. The number of nights that have thus been booked is indicated by bars which appear as each night is added.

This next screen shows a room overlaid with icons permitting the selection of room type(s). Four icons each 'unlock' further related icons to enable:

a) the number and type of occupant

b) the number and type of beds required

c) the type of bathroom facilities required

d) a range of other available facilities (such as TV).

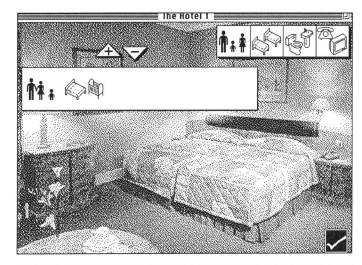

This screen shows the users their final completed selection.

The message is then revealed to the hotel in stages. Confirmation and the acceptability of each part of the message moves the sequence on. Unavailability brings up a range of alternatives.

The final message is sent back to the user who will then accept or reject the alternatives offered, continue the dialogue, and confirm a booking.

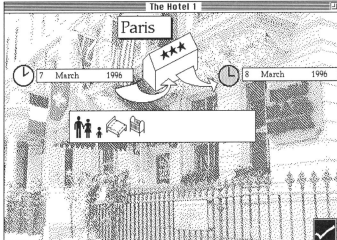

clone beside it, and then dragging that clone into the room which is shown as a rectangle; these mobile icons (dragable sprites) can also be deleted. More rooms can be requested, occupants and contents can be rearranged to suit. This method of presentation was felt to allow the user more flexibility in organisation than if each room had to be defined separately, and whilst no controlled tests have yet been conducted, the interface has been found to be intuitively obvious. In order to cue the user's understanding of the principles of organising a room, the screen opens showing one room with occupants. When a satisfactory

arrangement of rooms, occupants and facilities has been achieved, on 'mouse-up' the 'tick' item moves the user on.

This staged progression allows for user comprehension and alteration both throughout the screen sequences and at the point of final submission. The message is also revealed to the hotel in stages allowing for confirmation of the acceptability of each part of the message. If any facilities are unavailable, alternatives are presented to the user so that different choices can be made. The application does not pretend to be comprehensive but is an initial attempt to create a simple human-computer-human dialogue through icons.

Icons or illustrations?

Examples in this chapter have shown how the divide between illustration and symbol is becoming increasingly difficult to define. A recent search for screen icons produced largely cartoon and pop art figures or semi-realistic characters and objects. This could be as a result of the availability of clip-art, meaning that individuals are relieved of the need to design their own symbols and are free to download and modify a ready-to-use icon. It could also be part of the desire to make software resemble computer games. All of this matters little in terms of usage. If the symbol is generally recognisable it can do its job whatever the style. In the end, it is for the user, a new generation of computer literate students, to judge what they best relate to as symbol systems on their screens.

An interesting example of this merging of illustration and symbol occurs in an educational project in Chile. It is reported in Preston (1994). This article stresses how navigational aids and the whole graphic environment are vital to enable students to familiarise themselves with, and make full use of, startlingly new technology. The usage of the computer is enhanced by the introduction of illustrations of surroundings familiar to all – the town square. The details within the formalised representation of 'La Plaza' help the users to 'point and click' their way around the various functions of this innovative software.

Hearts

Cheeky Smile Envelope

Puppy Race Car

Fun Mad Professor

Toilet Paper Hamburger

Computer-generated symbols

This section is extracted from an article first published in 1995 in The Times Higher Educational Supplement *. Christina Preston is director of Project Miranda at the London University Institute of Education.*

Surfing towards the twenty first century. An educational multimedia network in Chile

The Enlaces Project started in Santiago, Chile's capital city. The network strategy the Enlaces team has developed is based on the universal Chilean experience of playing in the village or town square, La Plaza. This multimedia, networked software is designed to improve the quality of education, to decentralise curriculum development and to encourage teachers to be creative and innovative in tackling the problems they face. The network is proving a valuable tool for improving the communication skills and raising the self esteem of the student as well as providing in-service education for teachers.

Most importantly the Enlaces project is a response to the technologically driven changes in communication and education. The Internet is a new metaphor for independent learning that will probably have the most impact on educational processes in the long run. With so much

Figure 1. La Plaza: point of access to the system

information available on-line, do problem solving approaches and information retrieval skills become more important than a good memory? Remote messaging and multimedia communication challenge the notion of writer and reader, of the authority of published text and the nature of publication itself.

'La Plaza' (Figure One) is the software which coordinates the educational network managed by the Enlaces team. La Plaza is a metaphor that teachers and children can identify with. It simplifies the tasks that can be tackled on the network by relating them to the activities in a town square associated with a Post Office, a Kiosk, a Museum and a Cultural Centre. La Plaza is used for communication and education and the team are organised to expand the activities in each location and explore new strategies that decentralise planning involvement and encourage independent learning.

The post office (Figure Two) is a simple electronic mail system for children and teachers. The goal is to have an informal means for them to establish first contact, and go on to join working groups in the Cultural Centre or simply

Figure 2. The Post Office and its Mailboxes

exchange ideas and opinions on subjects of general interest. The children use this post office in the schools daily, writing letters with text and drawings about diverse topics: for example, how to make friends, tell fortunes, play chess and itemise what motivates them. Content in the form of sound and graphics is being explored in prototype versions. The final objective is to allow children to compose a multimedia document and to send it through the network. For this purpose, the network`s communication platform is based on the MIME standard.

The Kiosk offers a window for dynamic information. Multimedia based newspapers with text, graphics, sound, animation and video clips are being developed by the teachers and students themselves. The Kiosk also offers short multimedia based educational stories and vignettes as a stimulus to reading and writing prepared by the team. Through the Kiosk, the children can write and illustrate stories and offer them to children at other schools, something which motivates and entertains them and reinforces their self-esteem.

Figure 3. The Kiosk with its Newspapers and Stories

The museum is an information center with greater

permanence than the information contained in the Kiosk. Essentially the museum is a data base of information, experiences, demonstrations and uses of educational software along with the software itself.

The kiosk is for short communications whereas the Cultural Centre is a meeting place for developing longer and more structured collaborative projects among the students and teachers at different schools. It is simple to use bulletin board system with some multimedia capabilities. Electronic mail messages promote sociability, communication and increase the self confidence and self esteem of the students. A sense of culture is being fostered by access to information and participation in projects through interregional and international educational networks; expanding the student's global vision. Now that the project is becoming well known there are many requests from teachers around the world to devise joint topic work with Chilean students.

The Cultural Centre is also a place to establish communication among teachers about teaching and learning. Through the electronic network which forms the

Figure 4. The Cultural Centre and its current work areas.

backbone of this system, teachers are establishing personal ties and an exchange of experiences at local, regional, national and international levels.

Software development

The application of the word 'museum' to a software store is an interesting new twist to expectations since computer materials seem so recent. Locally produced software is robust and attractive. As the few books available do not relate to the students' daily lives the software redresses this balance: Birds of the Chilean Regions, Artists of Chile, The Human Body and The Mapuche Indian Ruca (Thatched Hut). An adventure, Martín the Explorer, set in the jungle, is being developed to improve motor functions, cognitive abilities and understanding of relationships. This is also a vehicle for researching the role of the computer in the cognition processes of student.

Many of the schools which are on the network are from the poorest and remotest regions. The greatest benefits have been to the Mapuche Indians who do not have a written language. They have felt embarrassed about their traditions and reluctant to use their oral language, Mapudungan, in school. Multimedia recording is allowing oral traditions to be maintained. Mapuche children who were only using Spanish are now keen to record a sound dictionary in Apuche and invent new words to keep the language alive. The irony is that they are moving from inadequate book information to a networked research culture which permits access to current databases on-line and CD-ROM storage. They are jumping 500 years of books and reinforcing a medieval oral culture.

Conclusions – Implications for designers today

The two projects reported in this chapter take images beyond the role of pictures as adjuncts to the written word, making them replacements to it. They are intended to cross language and cultural boundaries and together illustrate the extension of the designer's task once icons are no longer

static, and in addition can be interactive or three dimensional. All the skills that were required when graphic design was concerned solely with the layout of text and illustrations on a printed page will be needed, plus more. The designer's specialised task, once he or she is in command of the tools for initiating such programs, will be far from easy. The fact that a computer is involved will not make matters of judgement simpler. A machine is unable to make qualitative or aesthetic judgements on its own, however sophisticated its design software may be, a point stressed in *Computers and Typography* (Sassoon 1993).

Whether dealing with text or an iconic system for a computer interface it is first necessary to come to terms with the fact that the screen is not the same as a page. Where once the eye was trained to commence reading at the top left hand corner and proceed downwards, the same is not necessarily true of a screen. The initial focus of attention and the hierarchy of importance will depend on the designer's skill. The user's eye will proceed according to the importance given to the elements of icons, text or illustration. Spacing becomes even more important on the screen. Elements need to be contained coherently within their own space and clearly defined in space from the next element. Adequate space on the screen is more telling than boldness. A busy page is one thing but an overly busy screen is not only distracting but increasingly fatiguing to the reader. Designers must also bear in mind that, although they may be able to specify the trimmed size of a page, they may not have control over the end user's screen size.

Colour needs careful planning, even though (unlike print where the final production is consistent) the designer may not always have control over the end user's environment. Colour should be used to direct the eye rather than distract it. Subtle colours and contrasts should be considered. Eye fatigue and even more serious visual problems, caused by ill-advised use of colour, are being taken seriously.

Each of these design and layout factors will need consideration if computer generated iconic communication is to fulfil its promise. However neat our theoretical arguments may be, in real life other factors intervene. End users' interests should always be considered and those in

specialist fields should be consulted whenever possible. There is often a useful lesson to be learned from them – in humility if nothing else. The user's perception or interpretation of an icon may differ from the designer's, and there is often as much to be learned from those with problems as from so-called experts. It was reported by an observant colleague, who uses several symbol systems with patients, that adults and children alike frequently found that their own idea of an object did not coincide with the designers' perception and representation of it. When they had difficulty in associating an icon with their own perception of an object the users had great difficulty remembering that particular symbol.

More than one person working in the field has expressed the feeling that some designers of symbol systems seem so entranced by their own cleverness that they appear incapable of understanding that some users might not appreciate their personal vision. This seems to point to the desirability of making some symbol systems interactive. Then users (or carers) could insert their own version of any particular symbol for use in communication. This seems nearer to the use of personal handwriting, where the writing itself represents the users' attitudes and moods, and is in itself the way writers present themselves to the world. We have no problem in acknowledging that personal handwriting must be legible in order to be of any use to the reader. Likewise a symbol would need to be recognisable to the reader, preferably, but not exclusively without a glossary. Between the personal variation or standard handwritten word or symbol there is still plenty of room for flexibility.

With so much in mind, how can we plan ahead? While more and more ingenious technological advances take place in the area of computers, there is little evidence that experienced designers are having the influence that is so vitally needed in order to facilitate the acquisition of knowledge from the screen, whether via text or icon.

Honeywill has cited Davis (1995) who points out that, 'it is noticeable that most multimedia products bear clearly the fingerprints of the particular trades which have produced them – of television, of book publishing, of database design, etc. – failing often to establish any new aesthetic. The

designer needs to challenge what industry seems to consider, the orthodox of repackaging the same content within a different media according to the trade, while emulating the standards of other disciplines within the product.'

However I cannot entirely agree with what he has said. While accepting that multimedia design needs new attitudes, as well as new skills in addition to traditional typographic practices, this is a somewhat destructive attitude, putting all the blame on individual designers (though such remarks should not be taken out of context). It would be more useful to ask where the fault lies if multimedia productions fail in to reach a 'new aesthetic' – and what can be done about it? Such projects usually command a huge budget. They should have a knowledgeable director capable of giving informed guidance to young designers who may have the technical skills and new ideas and talent but lack, above all, experience. Older members of a design team, whose experience may well have been gained in other media, may also need expert guidance and to have their horizons broadened, but their balance and judgement will be invaluable.

Those worthy to be called designers must be capable of assimilating new skills and attitudes – just as those who preceded them made the jump from the written book to the printed one and took what was good from their previous experience to the new age. There are plenty of flexible and experienced designers with a thorough understanding of the sterner, pre-computer disciplines, in different media, to guide those who have little understanding, or even respect, for their skills. I am not only addressing students and training establishments – but much more pointedly, those who manufacture software. Their disregard of basic design principles is all too apparent. Take, for example, the deplorable state of educational software design. This can be seen in any school today, where our children are expected to learn from screen displays that actively discourage real learning, rather than promote the assimilation of knowledge.

The hard truth of the matter is that without the all important 'trained eye' and judgement of the experienced

designer, no amount of up to date attitudes or knowledge of multimedia techniques is of much use. One must be grafted on to the other.

The importance of all the elements of design, from the initial letter, sign, symbol or icon to the final screen design, must be acknowledged, alongside the technological ingenuity. Our young designers must learn some of the accumulated lessons resulting from five hundred years of printing as well as the all too beguiling techniques of computer graphics. Researchers, experienced typographic designers and those in the most advanced area of multi-media iconic communication need to work together and learn from each other in this exciting new field.

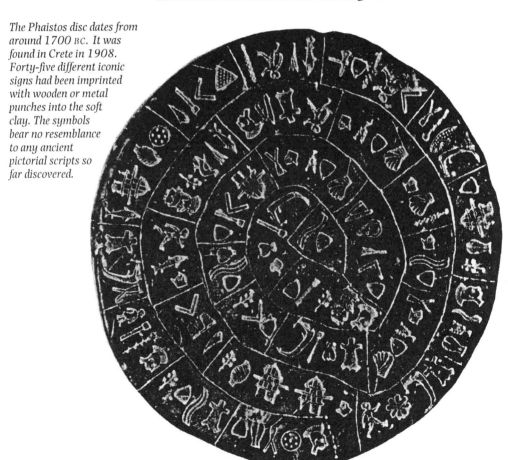

The Phaistos disc dates from around 1700 BC. It was found in Crete in 1908. Forty-five different iconic signs had been imprinted with wooden or metal punches into the soft clay. The symbols bear no resemblance to any ancient pictorial scripts so far discovered.

Postscript

This present study has traced the usage of symbol systems from prehistoric times to the present age of computers. Those who are shaping the future of iconic communication can see that valuable lessons are to be learned from history. The examples of modern computer generated symbol systems, shown in the second part of this book, demonstrate that contemporary changes in non-verbal communication are apt to bring advantages as well as disadvantages in their wake. Systems capable of survival will sometimes have to sacrifice a certain amount of individuality and expression to ensure their usefulness. For the universal recognition of an iconography, international cooperation is needed. Where safety is an issue, at sea and on the roads for instance, international cooperation to standardize signs has long been recognised. The spread of the computer and the advent of the information highway will increase this need. Yet such a step forward must be taken without destroying the confidence of those who may depend on some form of iconic communication, yet may have little access to computers nor perhaps the skill or desire to adapt, quickly, to a purely technological approach.

Today iconography is already a vital part of our infrastructure in many spheres of everyday life, but how successfully can the icon, if not replace, then support the written word, and how can we ensure that it becomes truly comprehensible to all potential users?

Before trying to answer these questions we ought to reflect, briefly, on the causes and the true nature of invention. Inventions and new developments hardly ever arise totally spontaneously. They arise whenever a particular need coincides with the means available to satisfy this need. Printing did not start with Gutenberg. Block printing, and printing with moveable type, had already been used in China for many centuries. All the ingredients necessary for printing were well known in 15th century Europe, such as the wine press and the technique of cutting type as practised by goldsmiths. The critical element for the

explosion of printing was the availability of cheap paper, (the first Bibles printed on parchment needed the skins of three hundred sheep). This coincided with the growing secularisation and the consequent spread of education, the rise of wealthy book collectors, and the need of the Church to provide proselytising texts for overseas territories.

As far as contemporary iconography is concerned the basic need lies, without doubt, in the international nature of life as it is now being conducted. We are, perhaps more than we realise, already living in the often forecast 'Global village'. Villagers and tribal people not only have similar needs, they have also a shared pool of common experience that make icons legible. Moreover, the multinational nature of many modern activities often make language and script a hindrance rather than an aid to communication. At the same time, the establishment and the growing sophistication of electronic information storage and the development of active communication networks provide the means to satisfy our new needs. We are thus only in the early stages of an area in which iconography will play an increasingly more important role.

This brings us to the second, and in some ways even more crucial question: how can we create icons that are truly comprehensible? Here too history can perhaps teach us an important lesson. As we have seen, the reason why prehistoric icons and those used by tribal societies functioned so successfully lay in the fact that the 'designer' and the 'reader' lived within the same community. In other words, both had access to a pool of shared experience. This is no longer the case. Nowadays, those who design icons often come from an entirely different background to that of the intended user. They may, in consequence, be more concerned with aesthetic considerations and their ability to create icons they can understand on the basis of their own experience than to assist the user.

To create a successful icon the designer must be able and willing to understand and evaluate the problem from the the point of view of the intended user. However brilliant or pleasing, an icon will not succeed if it does not speak the same language as those who are supposed to 'read' and use it. This is especially important if the icon is to operate on an

international level. Just as most western people cannot read Chinese characters, so a Chinese user might have difficulty understanding an icon that has been fashioned by a designer knowledgeable only in European ways of thinking and European conventions of visual expression. Why for instance, should it be assumed, at another level, that an child from an Indian or African village would readily recognise a cow as represented by an image based on a manifestly different breed? Neither the icon nor the design can exist in self-contained isolation.

Finally, will iconography replace writing? Here too we can perhaps learn from history. When systematic writing first evolved, in ancient Mesopotamia, it was used exclusively for the purpose of conducting business transactions. For a considerable time, matters relating to religion and literature – what we might term 'texts' – continued to be served by oral traditions. When iconography advanced from the static record to the descriptive it was the phonetic element that enabled it to do so. Even comprehensible icons without a phonetic element may not fully and reliably communicate.

Quite possibly we shall find ourselves in a similar position. Literary and humanistic texts may prefer the (probably electronically) printed book, commerce and business the supra-linguistic icon. That would leave handwriting to be reserved for our everyday personal needs. It is perhaps no accident that despite five hundred years of printing, and an ever increasing use of computers and iconography, the 20th century has also witnessed a rising interest in calligraphy at the personal level.

References

Backhouse J. (1981) *The Lindisfarne Gospels.* British Library.

Bankes G. (1977) *Peru before Pizarro.* Phaidon Press.

Barthel G. (1972) *Konnte Adam schreiben: Weltgeschichte der Schrift.* Du Mont Schauberg, Koln.

Bliss C.K. (1965) *Semantography (Blissymbolics).* Semantography-Blissymbols Publications, Sydney.

Bliss C.K. and MacNaughton S. (1974) *The book to the film Mr Symbol Man.* Semantography-Blissymbols Publications, Sydney.

Bonfante L. (1990) *Reading the Past: Etruscan.* British Museum.

Brinton G. (1886) *On the Ikonomatic Method of Phonetic Writing with Special Reference to American Archaeology.* Philadephia.

Brown M.P. (1990) *A Guide to Western Historical Scripts from Antiquity to 1600.* British Library.

Burt B. (1977) *Aborigines.* British Library.

Chadwick J. (1987) *Linear B and Related Scripts.* British Museum.

Coe M. (1992) *Breaking the Maya Code.* Thames and Hudson.

Colton H.S. (1949) *Hopi Kachina Dolls: with a Key to their Identification.* University of New Mexico, Albuquerque.

Cook B.F. (1987) *Reading the Past: Greek Inscriptions.* British Museum.

Coulmas F. (1976) *The Writing Sytems of the World.* Blackwell, Oxford.

Davies W.V. (1987) *Reading the Past: Egyptian Hieroglyphs.* British Museum.

Davis S. (1995) Developing courses in multimedia: is an art school the right place? Digital Creativity, *Proceedings of the 1st Conference in Art & Design Education*, CADE 95, University of Brighton, 144-9.

DeFrancis J. (1989) *Visible Speech – the Diverse Oneness of Writing Systems*. University of Hawaii, Honolulu.

Detheridge M. (1993) The Contribution of IT to Working with Symbols. *Symbols in Practice.* NCET.

Diringer D. (1968) *The Alphabet: a Key to the History of Mankind*. Hutchinson.

Duerden D. (1974) *African Art*. Hamlyn Publication Group.

Dunsmore S. (1993) *Nepalese Textiles*. British Museum.

Ferguson G. (1954) *Signs and Symbols in Christian Art*. New York.

Fox-Davies A.C. (1928) *The Complete Guide to Heraldry*. Thomas Nelson.

Gaur A. (1994) *A History of Calligraphy*. British Library.

Gaur A. (1984) *A History of Writing*. British Library.

Gaur A. (1980) *Women in India*. British Library.

Gaur A. (1979) *Writing Materials of the East*. British Library.

Harris R. (1986) *The Origin of Writing*. Duckworth.

Haugen E. (1966) *Language Conflict and Language Planning*. Harvard University Press, Harvard.

Healey J.F. (1990) *The Early Alphabet*. British Museum.

Honeywill P. (1994) Paper Made Computer Icons. *Intelligent Tutoring Media*. vol. 5, no. 1.

Honeywill P. et. al (1995) The Virtual Studio: Collaboration through digital networks *Intelligent Tutoring Media 6* (2) 63-72.

Houston S.D. (1989) *Maya Glyphs*. British Museum.

Jensen H. (1970) *Signs, Symbols and Scripts: an Account of Man's Effort to Write*. George Allen and Unwin.

King J.C.H. (1982) *Indian Life in North America 1600-1900. Thunderbird and Lightening.* British Museum.

Kress G. (1995) preface to *21st Century A-Z Literacy Handbook.* Preston C., Project Miranda, Institute of Education, London.

Lane H. (1984) *When the Mind Hears.* Random House, New York.

Lanham R.A. (1993) *The Electronic World: Democracy, Technology and the Arts.* University of Chicago Press, Chicago.

Lehner E. (1966) *American Symbols: a Picture History.* Dover Publications, New York.

Leroi-Gourhan A. (1965) *Hand und Wort; die Evolution von Technik Sprache und Kunst.* Institut d'Ethnologie, Paris.

Linotype (1989) LinoType Collection. *Mergenthaler Type Library*, Linotype AG p 3.

Lorimer P. (1994) *Reading in Braille*, RNIB.

Mallery G. (1893) Picture Writing of the American Indians. *10th Report of the Bureau of Ethnology*, Washington.

Manual of Heraldry (1856) Arthur Hall, Virtue and Co.

McLeod M.D. (1981) *The Asante.* British Museum.

McLuhan M. (1967) *The Gutenberg Galaxy.* Routledge.

Mealing S. and Yazdani M. (1990) A Computer-based Iconic Language, *Intelligent Tutoring Media*, 1 (3).

Moore A. (1977) *Iconography of Religion.* Rouledge, Kegan Paul.

Morris R.W.B. (1977) *The Prehistoric Rock Art of Argyll.* Dolphin Press, Poole.

Nida E. (1972) *The Book of a Thousand Tongues.* The United Bible Societies. Reading.

Olyff M. (1973) Designing the International Book Year symbol. *Icographic* No 5.

Papaspyrou C. (1990) *Gebardensprache und Universelle Sprachtheorie.* Signum Press, Hamburg.

Partridge S. (1994a) Development of the Sign Graphics System. *Laserbeam* 22, Summer 1994.

Partridge S. (1994b) Sign Graphics Working Party Recommendations. *Laserbeam* 22, Summer 1994.

Pekarik A (1988) Preface in *Dreamings; The Art of Aboriginal Australia*. Viking in association with The Asia Society Galleries.

Preston C. (1995) *Surfing towards the twenty first century*. The Times Higher Educational Supplement, 7 April.

Pitseolak (197-) *Pictures out of my Life*. OUP, Toronto.

Read K (1974) Sound Writing. *Icographic* no. 7.

Robinson A (1995) *The Story of Writing*. Thames and Hudson.

Safadi Y. H. (1978) *Islamic Calligraphy*. Thames and Hudson.

Sampson G (1985) *Writing Systems*, Hutchinson.

Sassoon R. (1985) *The Practical Guide to Lettering.* Thames and Hudson.

Sassoon R. (1993) *Computers and Typography.* Intellect.

Sassoon R. (1993) *The Art and Science of Handwriting.* Intellect.

Sassoon R. (1995) *The Acquisition of a Second Writing System*. Intellect.

Schmitt A. (1980) *Enstehung und Entwicklung der Schriften*. Herausgegeben Claus Haebler, Koln.

Shaw G.B. (1962) *Androcles and the Lion*. The Shaw Alphabet edition. Penguin.

Stammers, R. and Buckley, R. (1992) User performance with abstract and concrete computer icons and functions, *Proceedings of the First Workshop on Iconic Communication*, University of Brighton 1-7.

Stokes W.M. and Lee W. (1980) *Messages on Stone: Selections of Native Western Rock Art*. Utah.

Streicher H. (1928) *Die graphischen Gaunerzinken*. Kiminologische Abhandlungen,Vienna.

Stutley M. (1985) *The Illustrated Dictionary of Hindu Iconography.* Routledge, Kegan Paul, London,

Sutton P (1988) *Dreamings. The Art of Aboriginal Australia.* Viking in association with The Asia Society Galleries.

Thompson J.E.S. (1972) *Maya Hieroglyphs without Tears.* British Museum.

Tory G (1962) *Champs Fleury.* Dover Publications. New York.

Twyman M. (1976) The Significance of Isotype. *Icographic* No. 10.

Van der Post L and Taylor J (1984) *Testament to the Bushman.* Viking.

Vince J. (1987) *Creating Pictures with Calligraphy.* Hale, London.

Wagner A. (1978) *Heralds and Ancestors.* British Museum.

Wagner C.L.H. (1954) *The Story of Signs. From Earliest Recorded Times to the Present 'Atomic Age'.* Boston.

Walker C.B.F (1987) *Reading the Past: Cuneiform.* British Museum.

Walker W. (1969) Notes on native writing systems and the design of native literacy programs. *Anthropological Linguistics 11, 5, 148–166* Cherokee syllabary.

Weule J.K. (1915) *Vom Kerbstock zum Alphabet: Ersatzmittel und Vorstufen der Schrift.* Leipzig,

Yazdani M. and Mealing S. (1995) Communicating through pictures. *Artificial Intelligence Review, 9.*

Index

Aborigines (Australia) 14, 17, 20, 52, 70, 71
 see also churingas, Memory aids
Abbreviations 35, 36, 37, 38, 79, 94, 96
 see also Manuscripts, Signatures
Aegean 14, 23
Africa 17, 34, 35, 40, 52, 54, 178
 see also Ashante, Bushmen, Ewe (of Togo-
 land), Nigeria, Proverbs, Scripts (invented)
Alaska (script) 34
Al'kora, J. P. 10
Almanacs *see* Calendars
al–Mansur, *Caliph* 40
Alogonquin (Indians) 53
alpanas 56
Alphabets 12, 35, 76, 105, 117, 145, 156
– Aicher's' body alphabet 74, 158
– denoting quantity 68
– Kingsley Read's alphabet 67
– Shaw's alphabet 67
– Sir Thomas More's Utopia alphabet 68
 see also Braille, Numerals, Scripts
Altamira 14
America 34, 52, 53, 134, 158
– Central America 18, 33, 38, 158
– North America 17, 99, 118
 see also Chile, Mexico, Peru
Amerindians (American Indians) 13, 25, 52,
 71
 see also Alogonquin, Dakota, Haida, Hopi,
 Iroquois, Mapuche, Naskapi, Navajo,
 Winter counts, Wampum belts, Zuni
Amis *see* Kyoyu (script)
Amsterdam 51
Anatolia 23
Animal skins 17
ankh 32, 59
Apollinaire, G. 47
Arabic 35, 40, 44, 45
 see also Calligraphy, Numerals, Scripts
ARC (Arts Research into Communications)
 154, 161, 162, 163

– Atlantis Inter ARC Research Programme
 160
Argentine 73
Arp, H. 47
Art 12, 15, 35 43, 52, 59, 60
– tribal 52, 54, 70, 71
– wall paintings 14
 see also Religion, Stone Age
Armytage, P. G. 78, 79, 81, 96
Artifact 71
Aryabhatta 40
Ashante 20
Aztecs 33

Babylon 16, 20
 see also Numerals
Backer, R. 105, 114
Bamboo 19
Bamum (script) 35
Barbier 93
basmalah 45
Basu, H. 47
Batak 49
Beans, marked 18
 see also Moche
Beauchamp, P. 139
Belize 76
Benesh Movement Notations 122, 139, 140,
 141, 143, 147, 151, 153
 see also Movement notations
Bible 36, 45, 66, 118, 177
Binary code 39
Blind/visually impaired 73, 93, 94, 98, 100,
 101, 102
 see also Braille, Computers, Education
 (special needs)
Blissymbolism 73, 81, 82
Bodhisattvas 43, 44
Bones 13, 15
Braille 82, 92, 94, 96, 98, 100, 101, 102
– for Chinese 96, 97, 98

see also Computers, Education (special needs), UBC
Braille, L. 93
Branding/Tattooing 22
Briem, Gunnlaugur SE 63, 92, 98
 see also Braille
British Columbia 25
BSL (British Sign Language) 106, 107, 108, 109, 110, 111,114, 115, 116, 118
Buddha 43, 44, 58
Buddhism 33, 42, 43, 55, 58
 see also Bodhisattvas, Tantrism, Zen
Burgert, H. J. 48
Burtius, N. 125
Bushmen 68, 69

Cabbalah see Kabbalah
Calendars 33, 38
Calligrams 47
Calligraphy 43, 45, 178
– Islamic 44, 45, 47
– Chinese 34, 44
– contemporary 47, 48
– Japanese 42, 47
 see also Calligrams, Micrography, siddham, Zen
Canada 143
Carians 24
Cartography see Maps
Caxton, W. 23, 126
chakras 58
Charlemagne 28
Chemical formulae 64
Cherokee (script)118
Chile 166-171
China/Chinese 24, 27, 41, 43, 49, 66, 69, 70, 98, 167, 178
 see also Braille, Calligraphy, Moso, Naxi, Printing, Seals, Scripts
Christianity 16, 32, 58, 75, 127
– Coptic 32
– Evangelists 59
– Nestorian 40
– Saints 16, 59

see also Bible, Missionaries, Monks, United Bible Society
Choreography/Choreographers 121, 122, 139, 142, 148
 see also Dance/Dancers
churingas 21
Cicero 37
Clay tablets 11, 20, 29, 130
Cloth 17
Cocker, E. 46
Cocteau, J. 60
Codes 66, 73, 85, 93, 96, 99, 100, 102
 see also Braille, Computers, Cryptography, Scripts
Codex Boturini 29
Codification/conventionalization, of icons 31, 73, 74, 90, 122, 156, 176, 177
 see also Computers
Colours 12, 53, 65, 66, 71, 77, 159, 172
Computers 11, 29, 35, 61, 63, 75, 77, 79, 80, 81, 82, 83, 123, 146, 147, 166, 173, 176
– controlled by voice 102
– expression of emotions 156, 157
– generating music and dance notation 121, 123, 124, 129, 135, 137, 142, 148, 149, 150, 151
– generating navigational/interactive icons 154, 161, 162, 163, 164, 166, 167
– generating speech 80, 84, 89, 90, 94, 101, 103
– generating symbols/icons 63, 70, 72, 73, 75, 79, 82, 90, 91, 94, 95, 98, 100, 101, 105, 110, 114, 148, 158, 166, 169, 172, 176
 see also Braille, Chile, Copyright, Deaf people, Designers/Designs, Education (special needs), Hotel bookings, Internet, Music, Software
Confucianism 44
Conquistadors 33
Copper plates see Engraving/Engravers
Copy–books 46
 see also Writing masters

Copyright 73, 74, 137
Corelli, A. 129
Cosmology 56
Crete 8, 26, 39
 see also Numerals, Scripts
Cross, Tho. 129, 130, 131
Cuneiform see Scripts
Cup and ring sculpture 12
Curwen 123
Cryptography 32

Dakota (Indians) 17
Dance/Dancers 41, 54, 121, 139
– notation 121, 122, 139, 140, 142
 see also Computers, Software
Daoism 56
Day, J. 81
Deaf people 105, 106, 107, 116, 119
 see also Computers, Education (special
 needs), Sign graphics, Sign language
Decipherment 18, 32, 161
Denmark 134
Designers/Designs 61, 72, 75, 77, 123, 135,
 136, 155, 157, 158, 159, 166, 167, 168,
 169, 172, 173, 174, 175, 177
 see also Computers, Logos, Music, Printing
Diaries 38
Director Lingo Script 163
Disabled/handicapped people see
 Blind/visually impaired, Computers, Deaf
 people, Education (special needs)
Djed pillar 32
Druids 40
Drums 41
Dyslexia 85, 88
 see also Education (special needs)

Education 80, 81, 84, 90, 134, 151, 167,
 169
– bilingual 106, 115
– of designers 159, 174, 175
– special needs 73, 79, 80, 81, 82, 83, 84,
 85, 86, 87, 89, 93, 94, 95, 98, 101, 102,
 103, 106, 107, 114, 116, 152

 see also Braille, BSL, Chile, Computers, Sign
 language, Software
Egypt 23, 24, 31, 32, 33, 38, 41, 48, 158
 see also ankh, Djed pillar, Numerals
Ellis, L. 123, 124
email 156, 168, 170
Emoticons 156, 157
English 36, 67, 109, 111, 145
– as a foreign/second language 88, 105, 110,
 115
 see also Education, Sign graphics
Engravings/Engravers 123, 124, 129,131,
 132, 133
Eshkol–Wachmann Movement Notation 140,
 141
Eskimo (script) 66
Etruscans 35
 see also Numerals
Euphrates 31
Evans (scripts) 66
Ewe (of Togoland) 19

Far East 41, 43
Fertility (symbols) 13, 15, 16, 54, 55
 see also lingam, yoni
Feudalism 24
Feuillet, R. A. 139
Flags 23, 69
Flints 14, 15
Folklore 52, 55, 56
Font 71, 72, 73, 99,123, 148
– finger spell font 105
 see also Typography
Formosa 66
France 16, 24, 163

Gall (system for blind) 96
Gaunerzeichen 52
German 37
Gilgamesh 16
Gypsies 52
Global village 177
Graffiti 50, 72
Grammarians 41
Grater, A. 139, 151

Great Britain 134, 163
Greek/Greeks 24, 35, 40, 47
 see also Mythology
Gutenberg, J. 8, 11, 55, 155, 176

Hadlow R. 77
Haida (Indians) 25
Haiku (poem) 47
Hall marks, for gold/silver 23
Handwriting 11, 79, 81, 98, 148, 167, 168, 173, 178
 see also Abbreviations, Dance/Dancers, Manuscripts, Music
Harappa 26
Harvey, T. 123, 135, 136
Hebrew 45, 50, 51
Head, S. 105, 114, 115, 116
Heian period 42
Hedin, S. 20
Heraclitus 25
Heradotus 24
Heraldry 23, 24, 25, 69
Higden, R. 126
Hinduism 33, 54, 55, 56
– gods 23, 54, 55
– goddesses 54
 see also chakras, lingam, Shaivism, Shaktas, Tantrism, Vaishnavism, yoni
hiragana 42, 43
Hobo–signs 52
Hopi (Indians) 54, 71
Hotel bookings/brochures 72, 164, 165
House marks 23, 24
Hoyle, R. L. 18

Iceland/Icelanders 92, 93, 98
Iconology 59
Illiteracy 64
Impressionism 70
Incas 18
India 14, 23, 24, 40, 41, 52, 119, 121, 178
 see also Hinduism, Mysore, Rajasthan, Scripts
Indus Valley 11, 16, 26
 see also Seals, Scripts

Information Highway 74, 81, 176
Information Technology 9, 12, 79, 81, 85, 115, 117
 see also Computers, Education, Sign language
Ink 133
International Book Year 77
Internet 137, 160, 167, 170
 see also Chile, WWW
Invented scripts *see* Scripts
Iroquois (Indians) 53
Islam 40, 44
 see also basmalah, Calligraphy, Koran, Mosques, Muhammad, Muslims
ISOTYPE (International System Of Typographic Picture Education) 70, 160
Istanbul 45
Italy 17

Japan/Japanese 24, 41, 42, 43, 134
 see also Calligraphy, Heian period, hiragana, Physiotherapy, Scripts
Joseph I, Emperor of Austria 25
Judaism *see* Hebrew, Kabbalah, Masoretic texts, Micrography, Tetagrammaton, Torah

Kabbalah 50, 51
kachinas 54
Kaempfer, E. 37
kalmosin 51
Kauder (script) 66
ketav ainayim 51
Keyboards 101, 114, 136, 137, 144, 156
– overlay 85, 86, 89, 90
Koehler, L. 70
Koran 44, 45, 69
Korea 44
Kress, G. 155
Kyoyu (script) 66

Labanotions 140
Language 7, 64, 72, 81, 82, 83, 106, 116, 118, 155, 171
– visual 156, 159, 160
 see also BSL, English, Scripts, Sign language

Lascaux 16
Laserbeam 106
Latin 33, 36, 37
Leaves 15
Leibnitz, G. W. 81
Lima 18
Limbu 57
Lindisfarne Gospels 46
lingam 55
Literacy 66, 80, 81, 84, 89, 106, 114, 118,
 119, 135, 152
 see also Computers, Education
Lloyd, G. 86
Logic 81, 82
Logograms 33, 155, 156, 157, 161
Logos 24, 25, 27, 69, 72, 73, 74, 75, 76, 77,
 157
 see also Designers/Designs
London 46, 50, 69
Lord of the Beasts 16
Lucas (system for blind people) 96
Lute Tablature 124

Magic 15, 35, 53
Makaton 83
mandalas 56
mantras 43
Manuscripts 11, 33, 37, 38, 46, 122, 132,
 134
 see also Abbreviations, Music
Maps 20, 21, 22, 65
Mapuche (Indians) 171
Marcus Tullius Tiro 37
Morocco 44
Masks 14, 54
Masoretic texts/notes 45, 46
Mathematics 64, 99
 see also Binary code, Braille, Numerals
Mayas 18, 32, 33, 38, 76 , 156, 157, 158,
 161
 see also Binary code, Calendars, Numerals,
 Scripts
Memory aids 10, 16, 17, 18, 19, 20, 30, 40,
 41, 49, 53, 86

 see also Logos, Maps, Music notation
Merbecke, J. 127
Mesopotamia 25, 26, 29, 30, 31, 40, 51, 178
 see also Seals, Scripts
Mexico 23, 33
Miao *see* Pollard (script)
Micmac *see* Kauder (script)
Micrography 45
Middle Ages 36, 37
Middle East 11, 22, 30, 41
Midewiwin 53
Mime 122
Miro, J. 60
Missionaries 18, 22, 33, 66
Mnemonic devices *see* Memory aids
Moche 17, 18
Mohenjo–daro 11
Monks, *as copyists* 124, 135
Monotype 71
Moon, W. 93, 94, 95
Moso 49
Mosques 45
Movement notation 121, 122, 139, 143,
 144, 145, 146 153
– for clinicians 151, 152
 see also Dance/Dancers, Phsiotherapy
Muhammad, the Prophet 40, 44, 47
Muir E. 47
Music 40, 99, 121, 122, 123, 124, 129,
 135, 136
– by computer 134
– folk music 121
– notation 40, 41, 100, 121, 122, 124, 152
 see also Engravings/Engravers, Manuscripts,
 Neumes, Printing
Muslims 52
 see also Koran, Mosques, Muhammad
Mysore 55
Mythology, Figures from 59, 89, 110

Nagas/Nagastones 55
Naskapi (Indians) 53
National Council for Education Technology
 80

Navajo (Indians) 71
Naxi 49
Nepal 57
Neumes 41
Neurath, O. 70
New York 50
Nicholson, B. 60
Nigeria 50
Njoya, *script inventor* 35
nomina sacra 37
Norman conquest 24
Norway 118
Notitiae Malabaricae 37
Novell, M. 130
Novello, *music publishers* 123, 124
Nsibidi 50
Numerals 38, 39, 68, 124

Ogham *see* Scripts
Olympic Games 74, 75
Oral traditions 11, 17, 30, 53, 80, 103, 106, 119, 171, 178
Orthography 116, 118, 119
 see also Spelling
Ottoman Turks 28

Painting 34, 71
Pakistan 16
Palaeolithic Period(s) *see* Stone Age
Palestine 23
Pamphlets 33
Paper 23, 110, 118, 133, 142, 159, 177
Parchment 124, 177
Partington, A. 68
Pater noster 33, 67
Pen–cases 32
Persia/Persians 40, 47
Peru 17, 18, 19
Philosophy *see* Confucianism, Buddhism, Daoism, Zen
Phoenicians 8, 119
Phonetic elements, *of icons* 31
Physiotherapy 122, 139, 151, 152
Picasso, P. 60

Pickering, W. 127
Pictorial Statistics Inc. 70
Piette (French scholar) 14, 15
Plainchant 41
 see also Music
Political parties, *using icons* 64
Pollard system 66
Polynesia 52
Pompeii 50
Pottery marks 23, 34
Printing 11, 38, 46, 125, 129, 148, 170
– of music 123, 124, 129, 132, 135, 136
 see also Braille, Caxton, Designers/Designs, Gutenberg, Typography
Property marks 22, 24
 see also Branding/Tattooing, Memory aids, Seals
Proto–Elamites 29
Proverbs 19, 20
Ptolomaic period 32
Punctuation 38, 44, 68
pustaha 49

quipus 18

Rai 57
Rajasthan 57
rangolis 56
Rebus 31, 33, 35, 83, 156
 see also Scripts, Writing
Religion 12, 29, 31, 43, 52, 53, 70
 see also Buddhism, Christianity, Daoism, Hinduism, Islam, Shamanism, Totemism,
Ripa, C. 59
Rituals 15, 32, 54
RNIB (Royal National Institute for the Blind) 94
Road signs *see* Traffic signs
Rome/Romans 32, 36, 50
 see also Numerals
Royal School for Deaf People 106
Runes *see* Scripts
Russia 17

Sand 15, 71
San Diago de Compostella 59
San Diego 22
San Francisco 22, 54
Scandinavia 17, 24
Science 81, 99
Scotland 12, 69
Scribes 32, 36, 46, 48, 66, 124, 156, 157
 see also Calligraphy, Monks, Writing
 masters
Scripts 14, 15,29
– alphabetic 17, 35, 36, 70, 155
– Arabic 44, 45
– Chinese 19, 33, 34, 42, 70, 119, 178
– consonantal 8, 14
– cuneiform 30, 31, 51
– Egyptian hieroglyphs 20, 29, 31, 32, 48,
 64, 155, 156
– ideographic 18, 66, 68, 70
– Indian (subcontinent) 119
– Indus script 26
– invented 34, 35, 66, 67, 118
– Mayan glyphs 38, 156, 157, 158, 160,
 161
– Ogham 40
– phonetic 11, 12, 31, 32, 35, 53, 66, 68,
 70, 156,
– pictographic 30, 53, 64
– Runes 40
– secret 48, 50, 51, 52
– syllabic 14, 42, 64, 66, 118, 119
 see also Calligraphy, Numerals
Sculpture 71
Seals 11, 16, 25, 26, 27, 28, 31
 see also Signatures
Secret Societies/Messages 50, 52, 66
Semantics 81, 117, 146, 159
Semantography 81
Sequoyah, script inventor 118, 119
Sexual symbols see Fertility, lingam, yoni
Shaktas 55, 56
Shaivism 23, 55
Shamanism 53
Shaw, G. B. 67

Shells 15
Shiva 16, 23, 54, 55, 56
Shorthand/Stenography 36, 96
Siberia 10
siddham 43, 44
Signatures 13, 14, 22, 25, 27, 28, 64, 69,
 72, 79
 see also Logos, Seals
Sign graphics 104, 107, 110, 111, 112, 113,
 114, 115, 117
 see also Computers, Sign language
Sign Graphics Working Party 116
Sign language 82, 83, 105, 107, 110, 114,
 115, 118, 119, 167
 see also BSL, Computers, Education (special
 needs), Font
Sigsymbols 83
Simias 47
Singing 124
 see also Music, Plainchant
Sociolinguistics 114
Software 89, 90, 94, 102, 114, 134, 135,
 144, 166, 167, 168, 169, 170, 179
– for music 134, 135 136
– for dance/movement notation 144
 see also Braille, Computers, Education
Southeast Asia 41
Spain 14, 15, 40, 163
Spacing and layout see Designers/Designs
Special needs see Braille, Education, Sign
 language, Speech
Speech 83, 84, 153
– loss of 79
– finger spelling 40, 105, 107
 see also Education (special needs)
Spelling 11, 109, 111, 118, 145
Sponsorship Research International 75
Stone Age 12
– art of 13, 14, 15, 24, 29, 52, 70, 71
Stones 12, 15, 17, 21
Stylus 30
Suleyman I, Sultan 28
Sumatra 49
Sumerians 26, 30, 66

see also Numerals
Symbol Users Advisory Group 91

Tabloid press 33
Taiwan 66
Tallies 13, 19
Tantrism 55, 56
 see also chakras, mandalas, mantras
Tetragrammaton 51
Textiles 19, 57, 69
Thomas, D. 47
Thunderbird 52, 54
Tibet 56
Tigris 31
Tironian Notae 36
tocapus 18
Tomlinson, K. 139, 140, 144
Topkapi Museum 45
Torah 51
Tory, G. 68
Totemism 21, 25
Trade and guild signs 23, 69
Traffic signs 20, 65, 83, 176
Tree of Life 44, 57
Trikona 55
triratna 58
Tughra 28
Turkistan 20
Typography 65, 70, 72, 75, 76, 77, 96, 123, 124, 126, 135, 136, 151, 155, 156, 158, 172, 174
 see also Braille, Computers, Designers/Designs, Engravings/Engravers, Font, Logos, Music notation, Sign graphics

UBC (United Braille Code) 99, 100
United Bible Society 66
Universities 36, 48, 105, 143, 152, 167
Uyangas 50

Videotape technology 119
Vienna 70

Wachmann, A. *see* Eshkol–Wachmann Music Notation
Walsh, J. 131
Wampum belts 17, 53
Watermarks 23, 24
Weaving patterns 57
 see also Textiles
Whistler, J. A. M. 28
Wilson, D. 162
Winter counts 17
Women 56, 57
– as calligraphers 42, 43
Wood 15, 17, 21
Woodland School, Surrey 85, 86, 89
Words, *as icons* 69
Writing 17, 29, 81, 82, 83, 116, 155
– development of 12, 22, 30
– direction of 30, 94, 95, 140
– origin of 14, 35
– Romanisation (of non–western systems) 119
 see also Calligraphy, Computers, Handwriting, Sign graphics, Scripts, Spelling
Writing implements *see* Ink, Pen–cases, Stylus
Writing masters 11, 46, 68
Writing materials *see* Animal skins, Bamboo, Beans, Bones, Clay tablets, Cloth, Leaves, Paper, Parchment, Sand, Shells, Stones, Textiles, Wood, Vellum
WWW (World Wide Web) 155

Xunantunich 76

yoni 55
Yukaghir 10
Yule, I. 98, 99, 101, 102

Zen 12, 43, 60
 see also koan
Zuni (Indians) 71